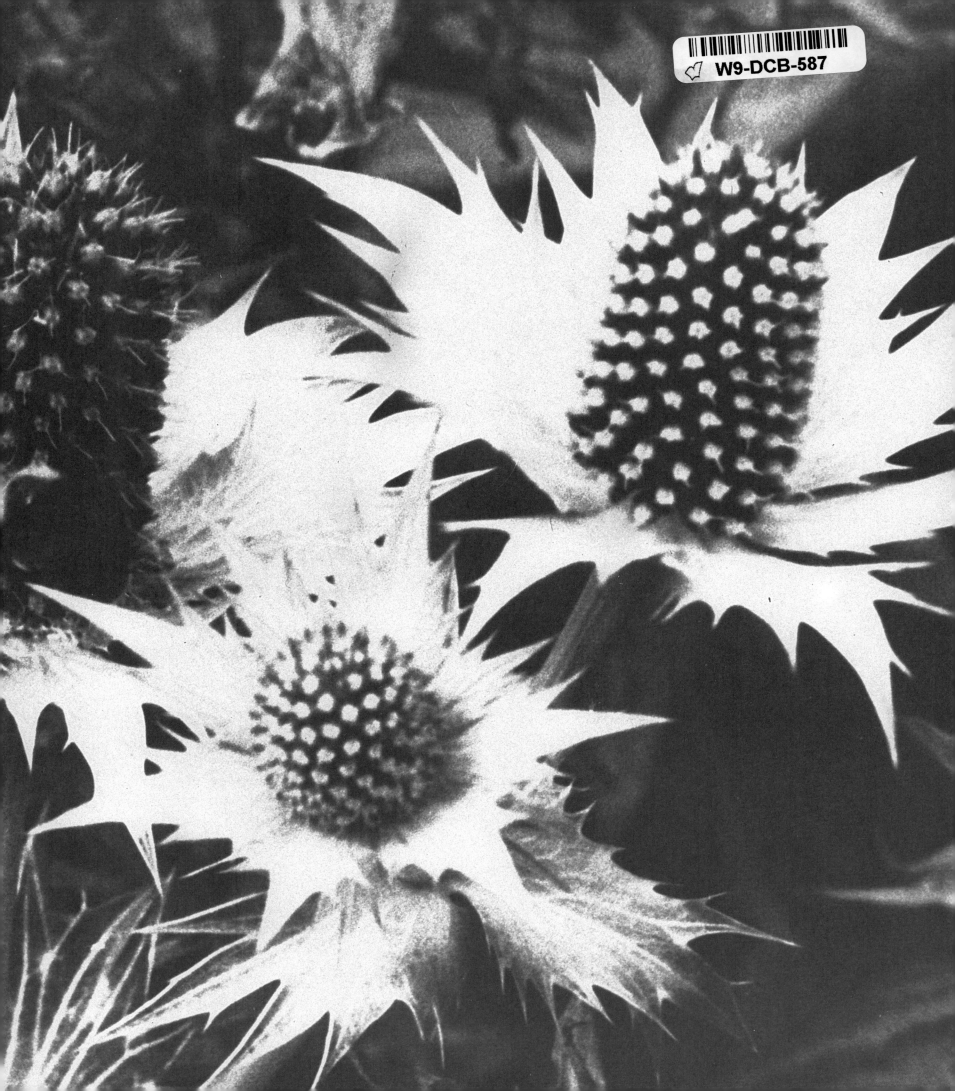

If Passion were a Flower...

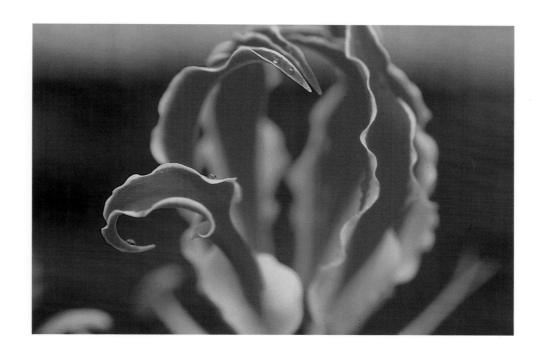

For Colleen...
In celebration of our most passionate friendship.

If passion is a flower
Then my eyes unfold rich colours —
my senses,
sensuous — so many layers
The closer I look
the more I see...

If passion is a flower
My hand strokes velvet
Soft, curves
Fingers travel new roads...
My lungs fill,
Intoxicated — I am drunk
on nectar so sweet...
Light headed — heart heavy
Movement is slow
Pulse is racing
Surely if passion is a flower —
it is you!

Conchita Fonseca, 1989

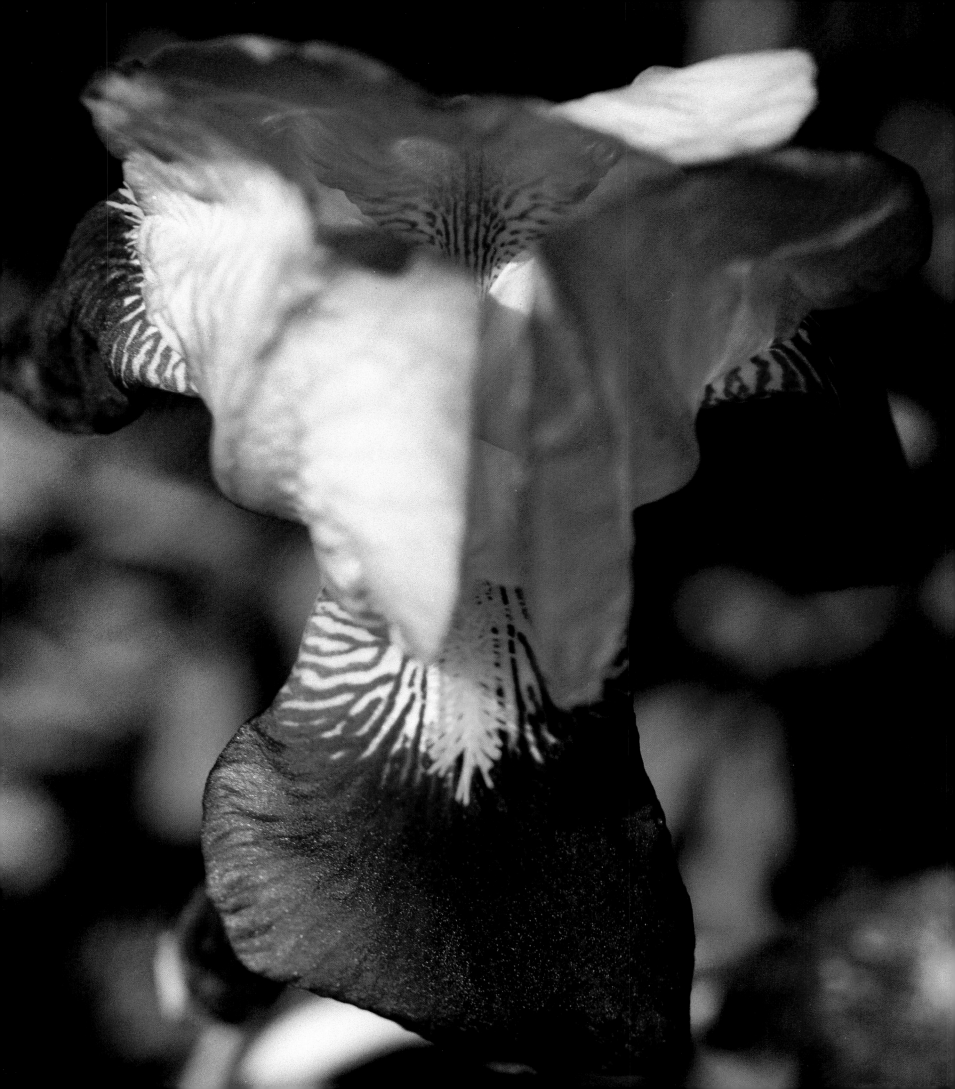

If Passion were a Flower...

Lariane Fonseca

Spinifex Press

List of Plates

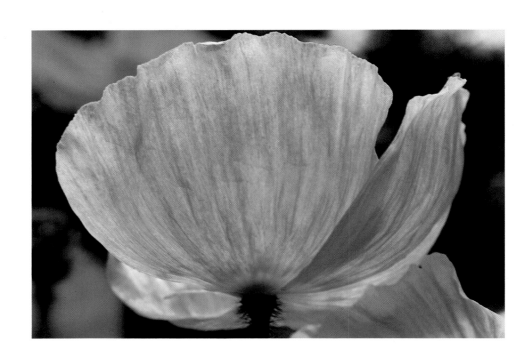

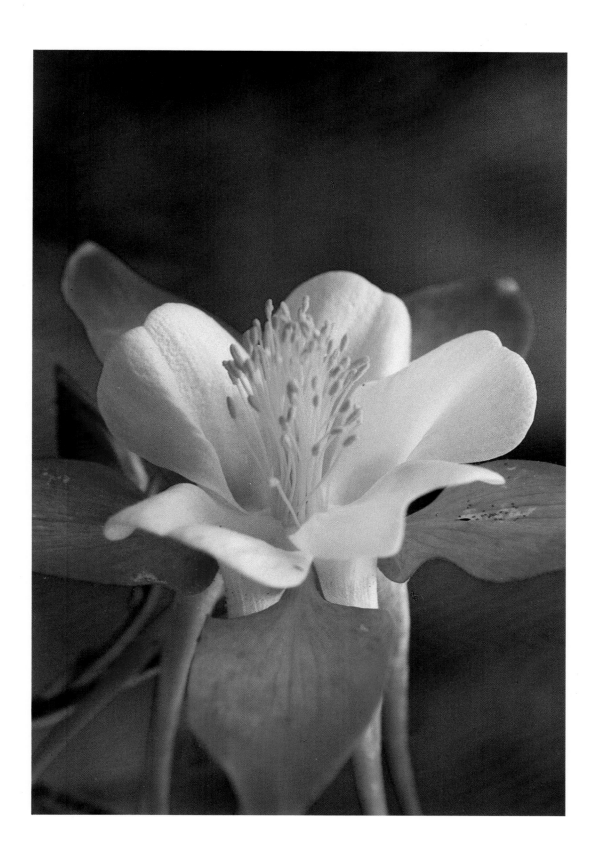

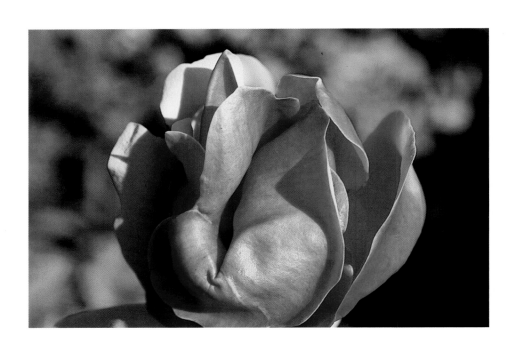

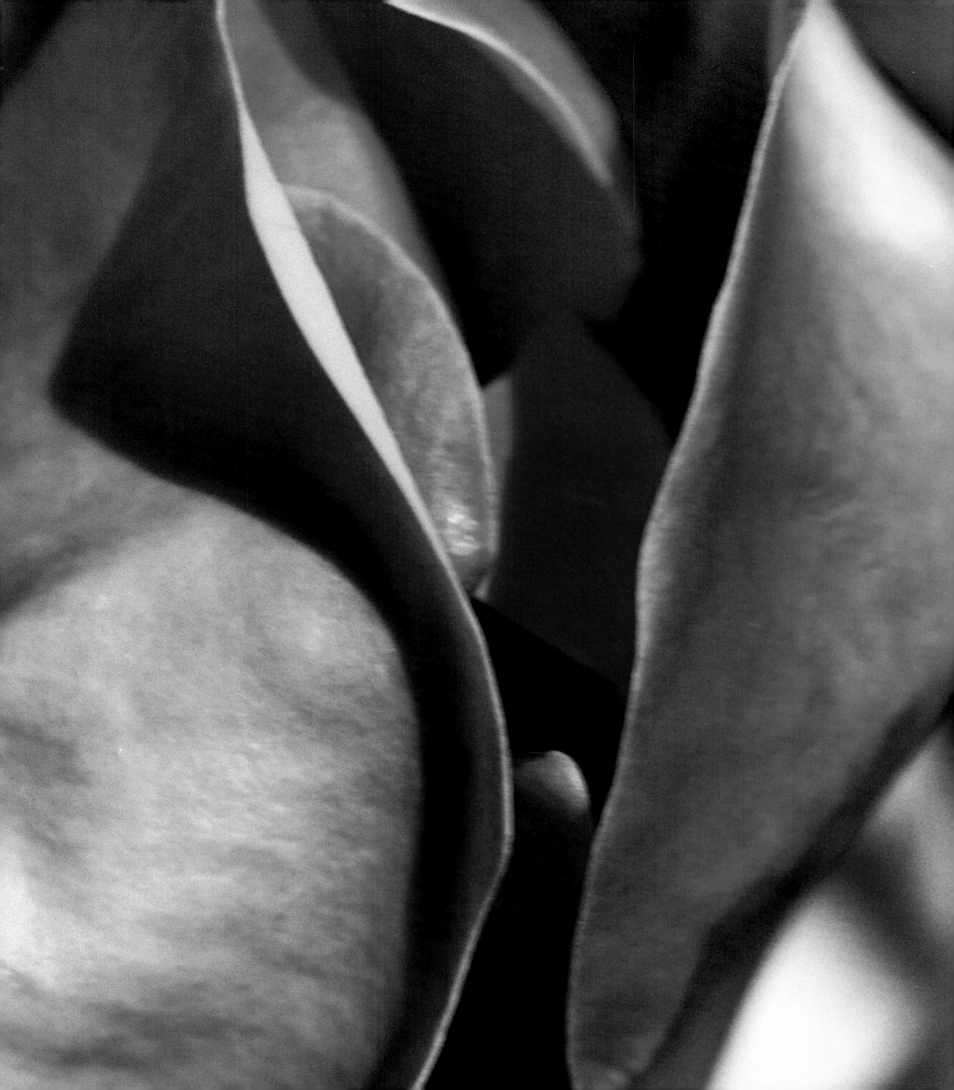

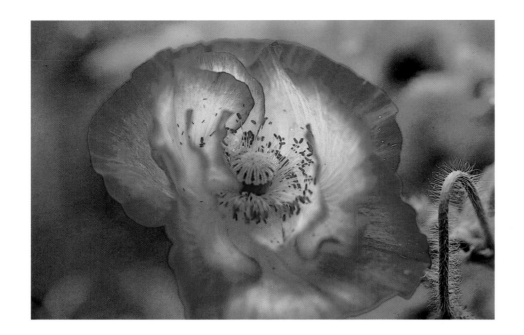

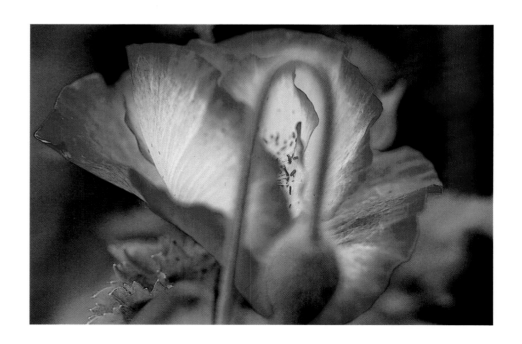

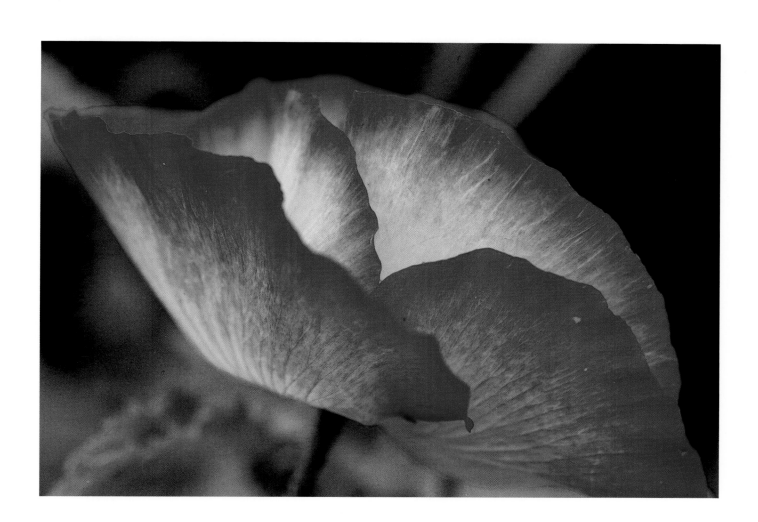

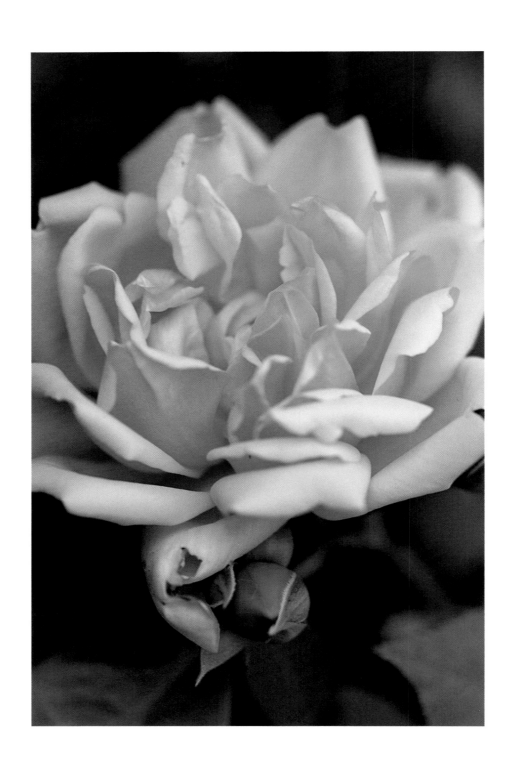

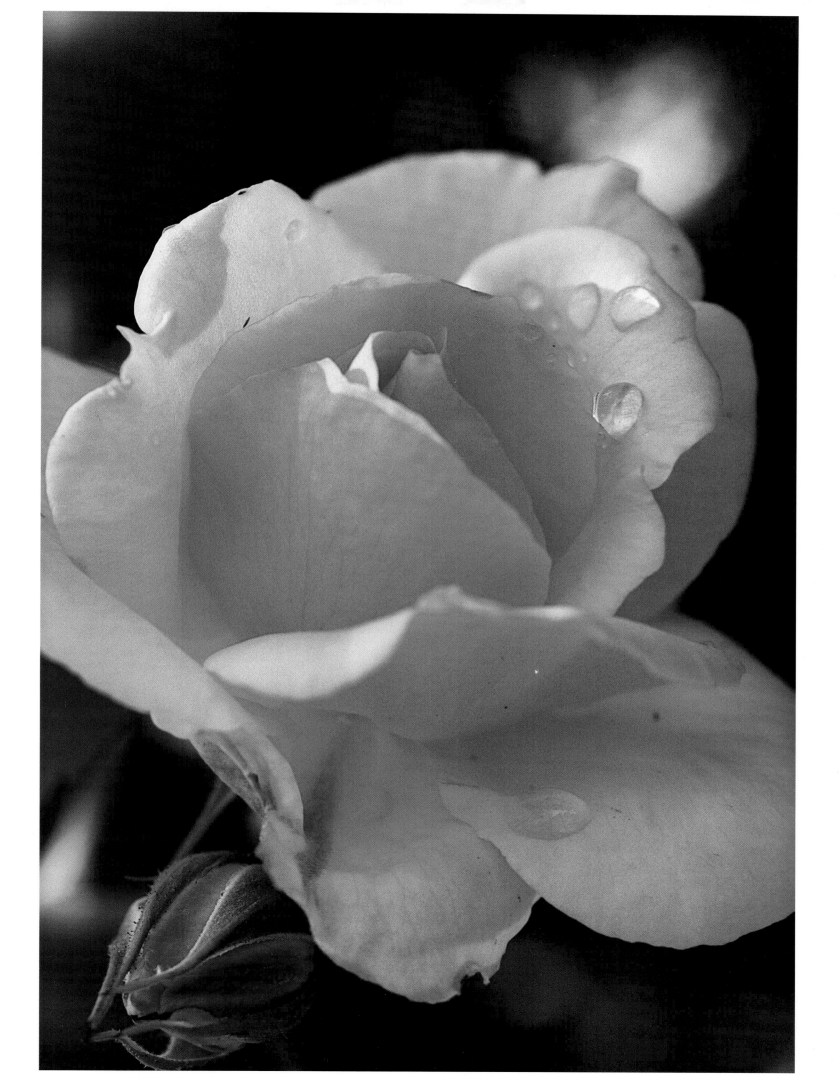

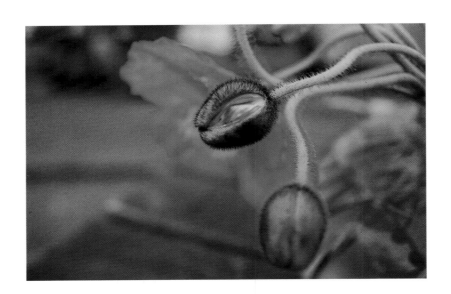

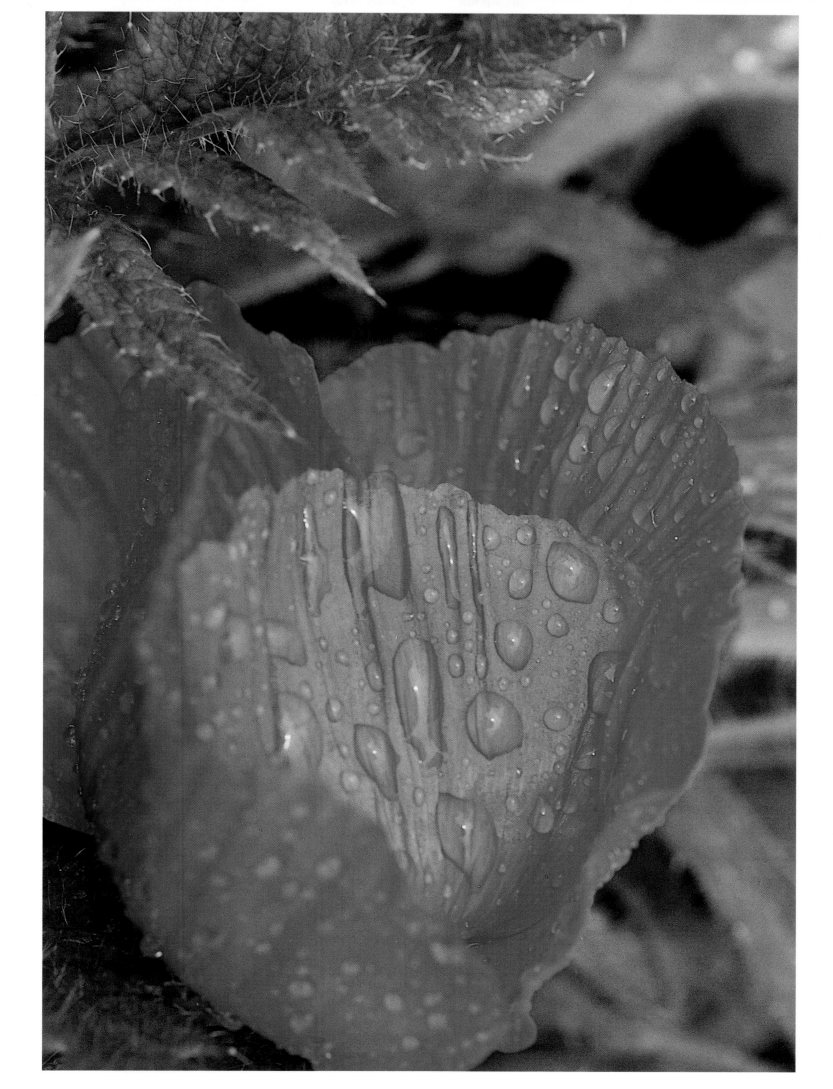

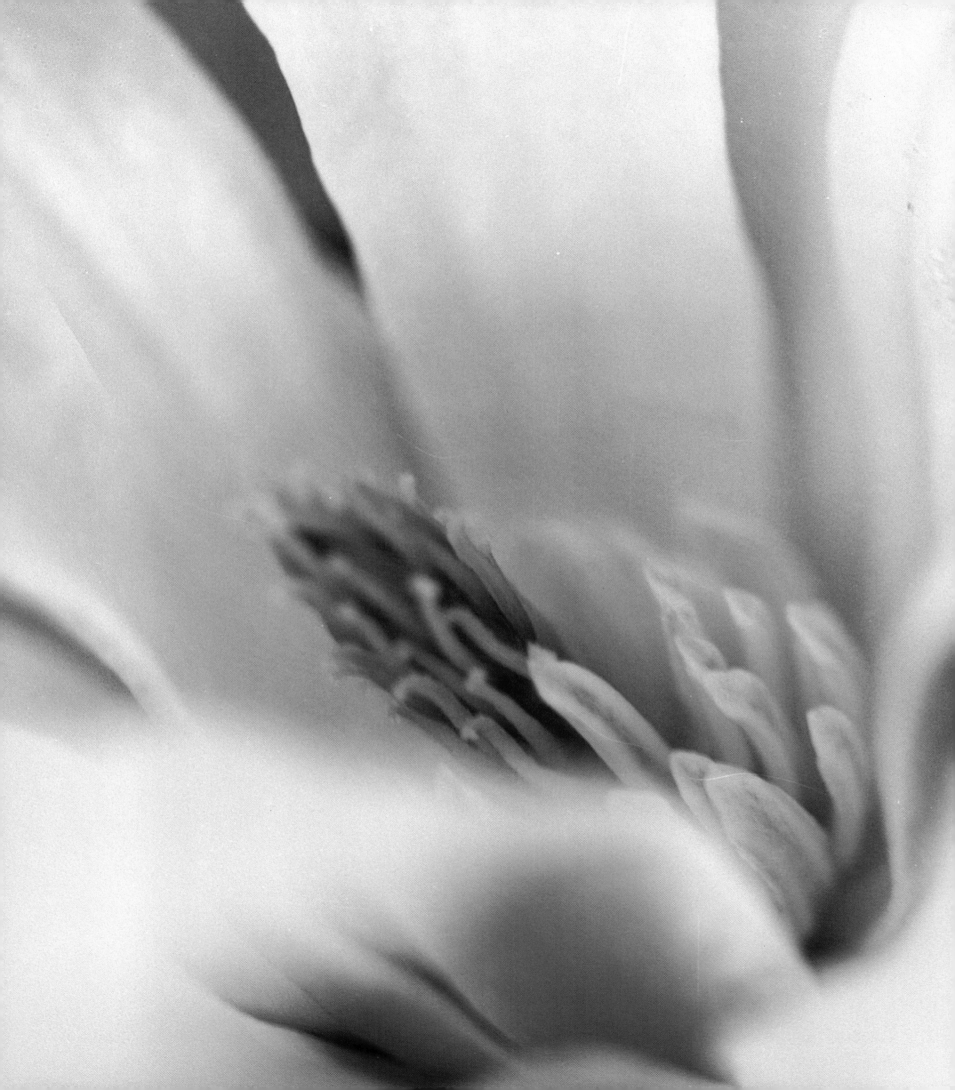

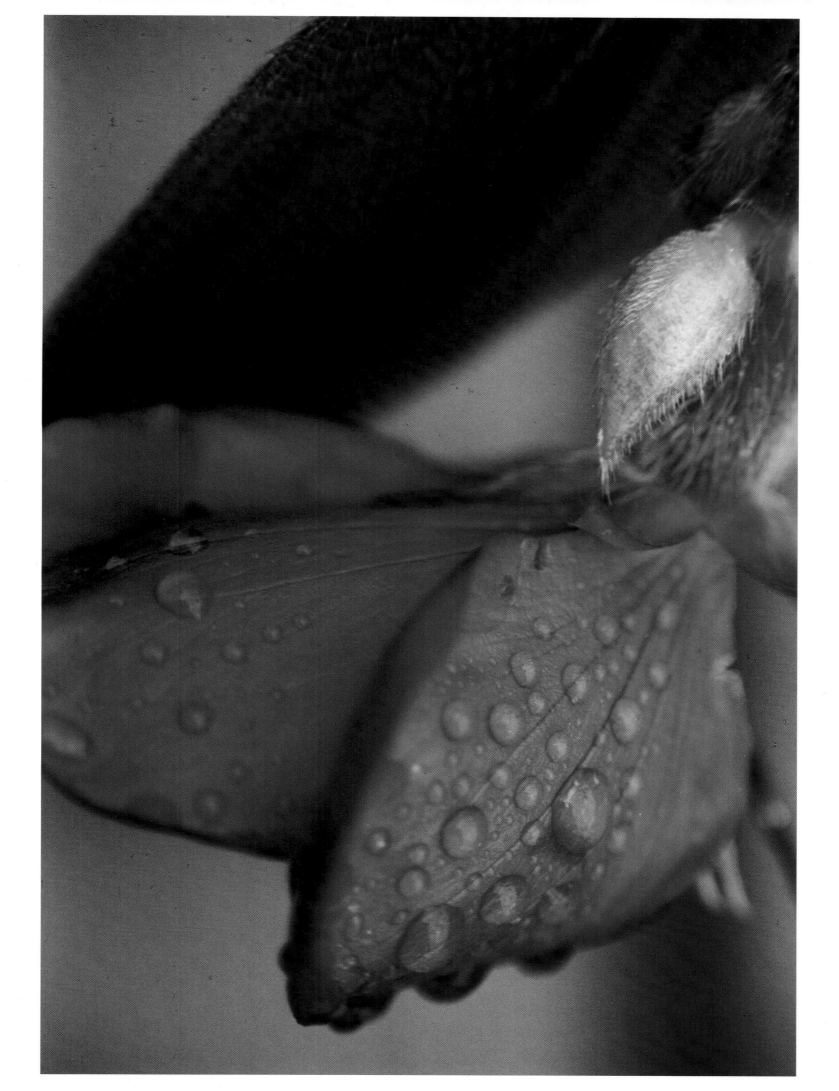

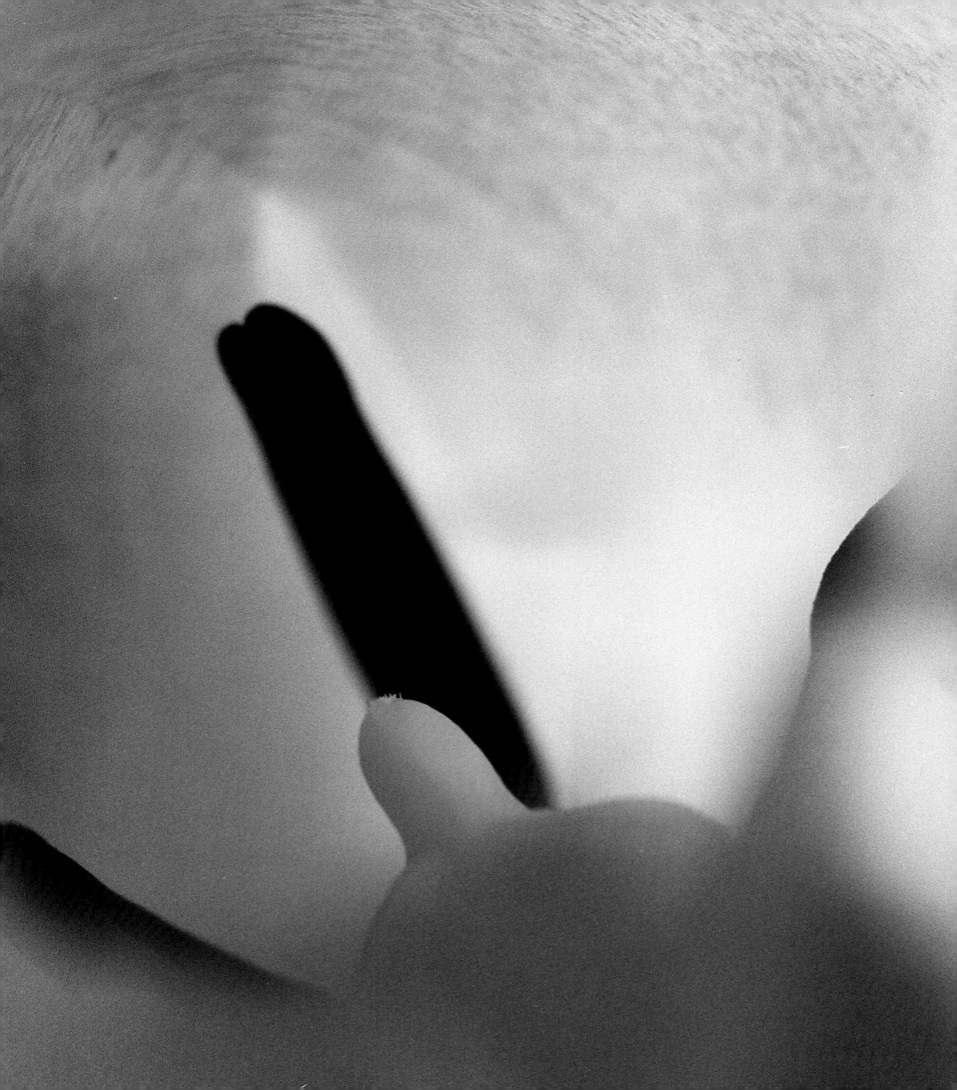

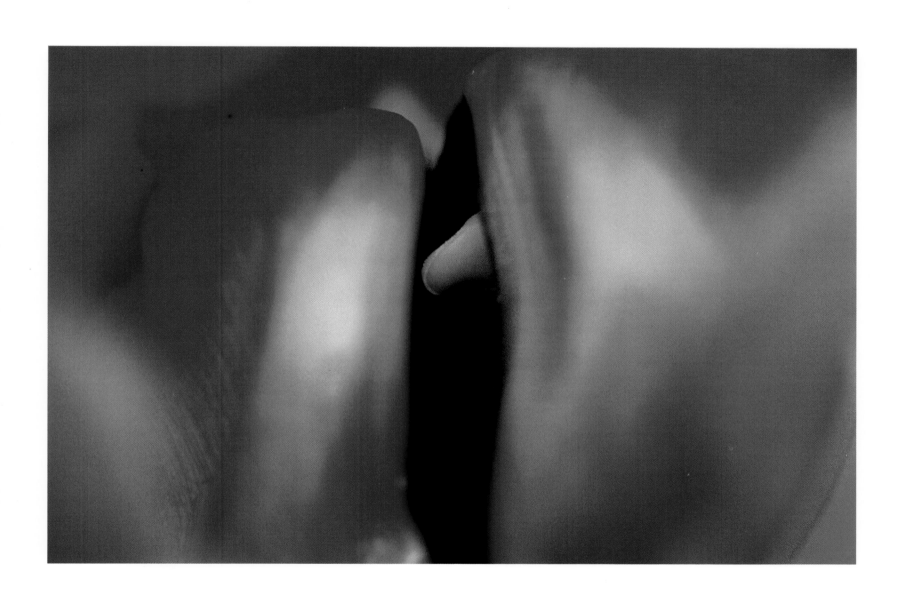

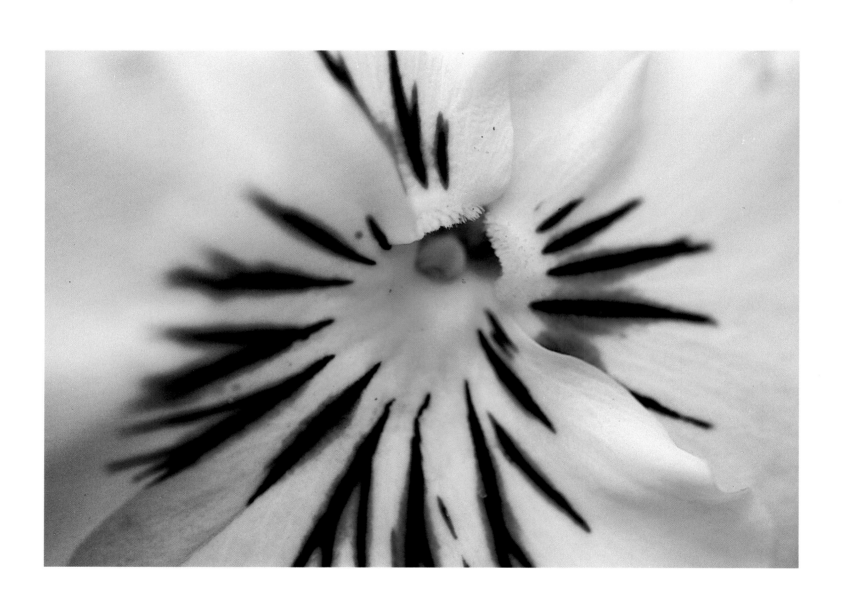

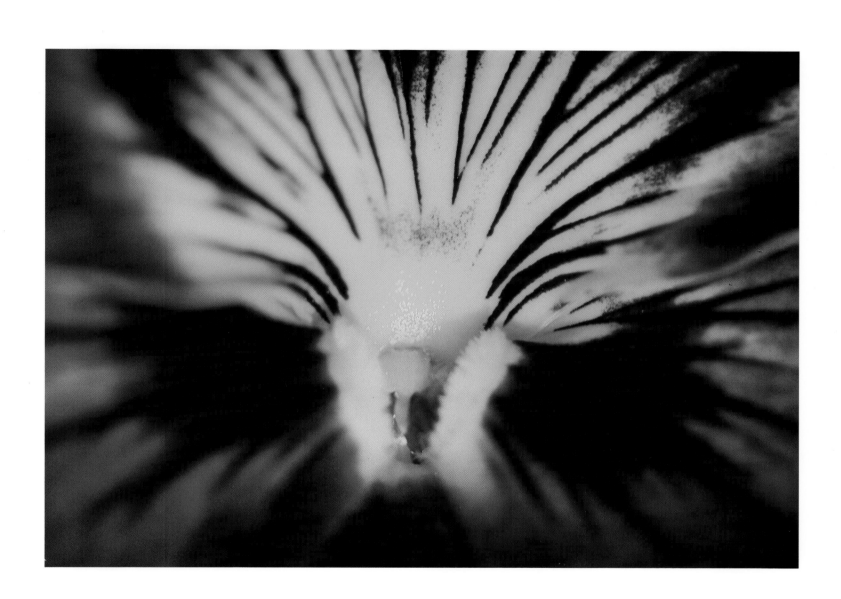

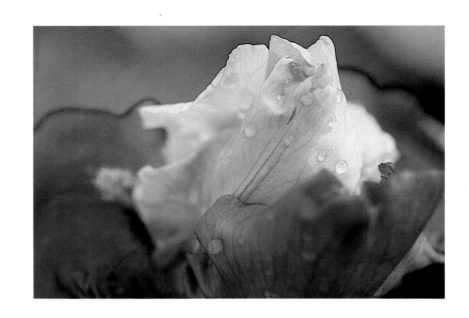

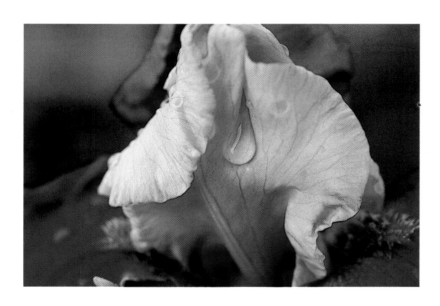

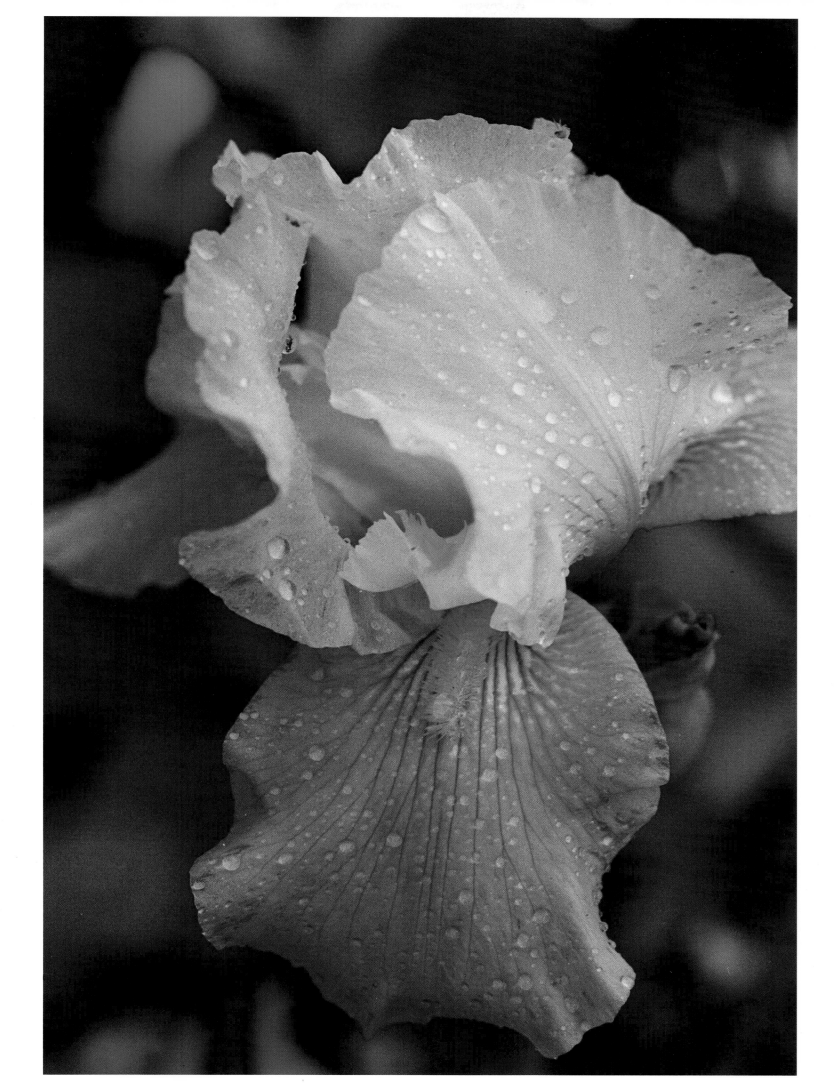

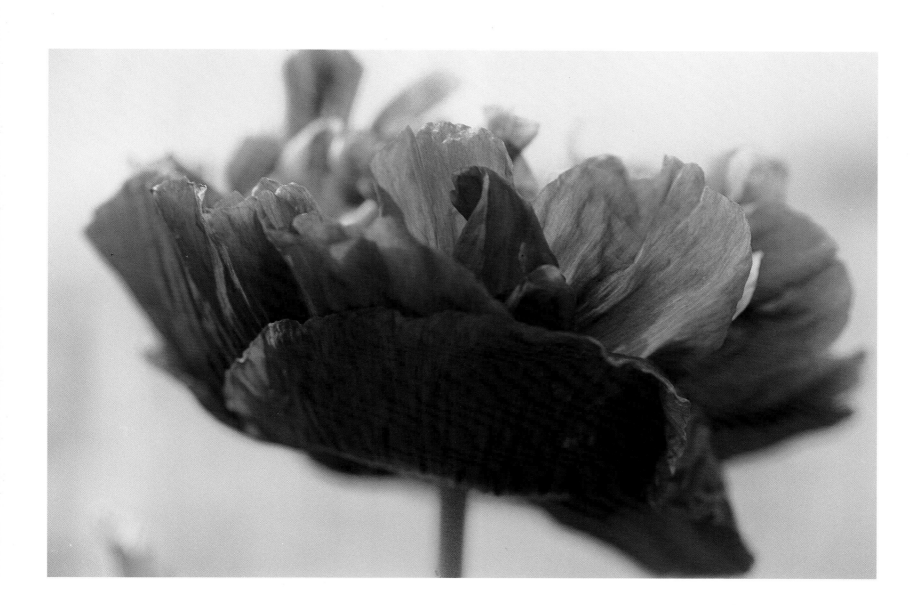

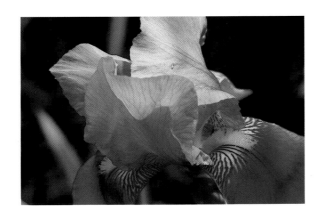 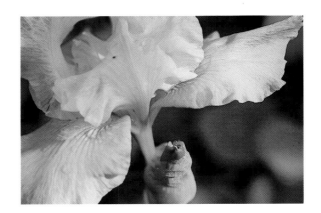

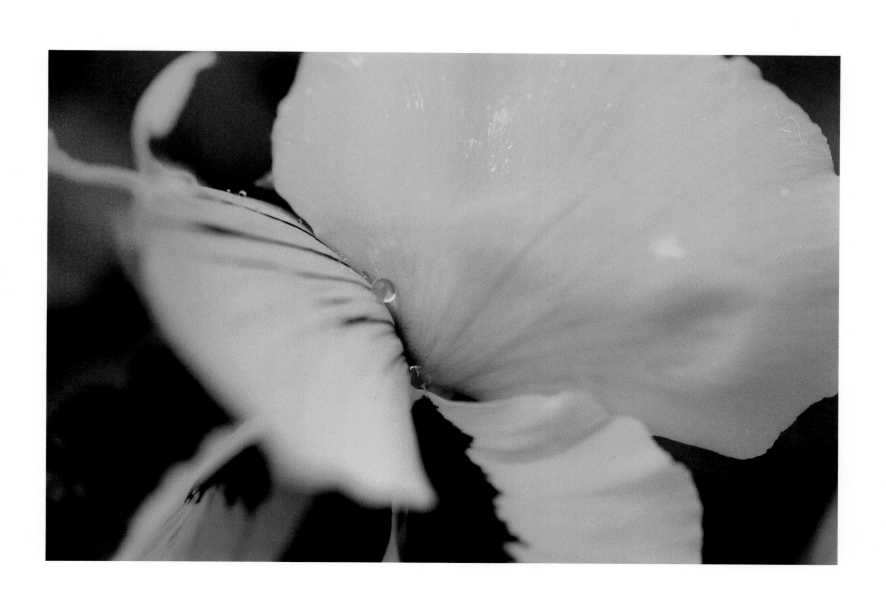

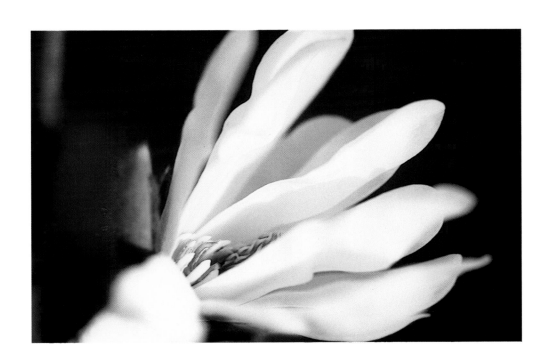

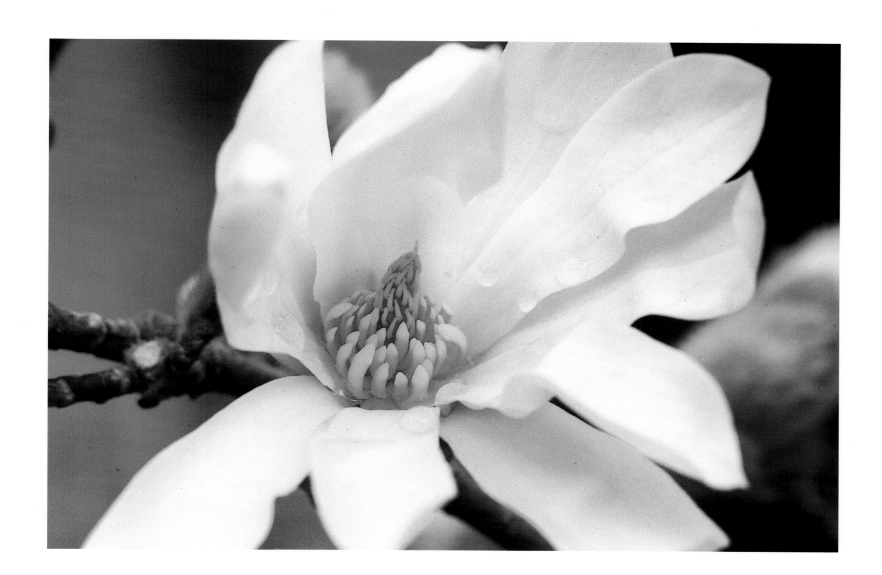

I give her the rose with unfurled petals.
She smiles
 and crosses her legs.
I give her the shell with the swollen lip.
She laughs. I bite
 and nuzzle her breasts.
I tell her, ``Feed me on flowers
 with wide open mouths,''
and slowly,
 she pulls down my head.

Suniti Namjoshi, 1980

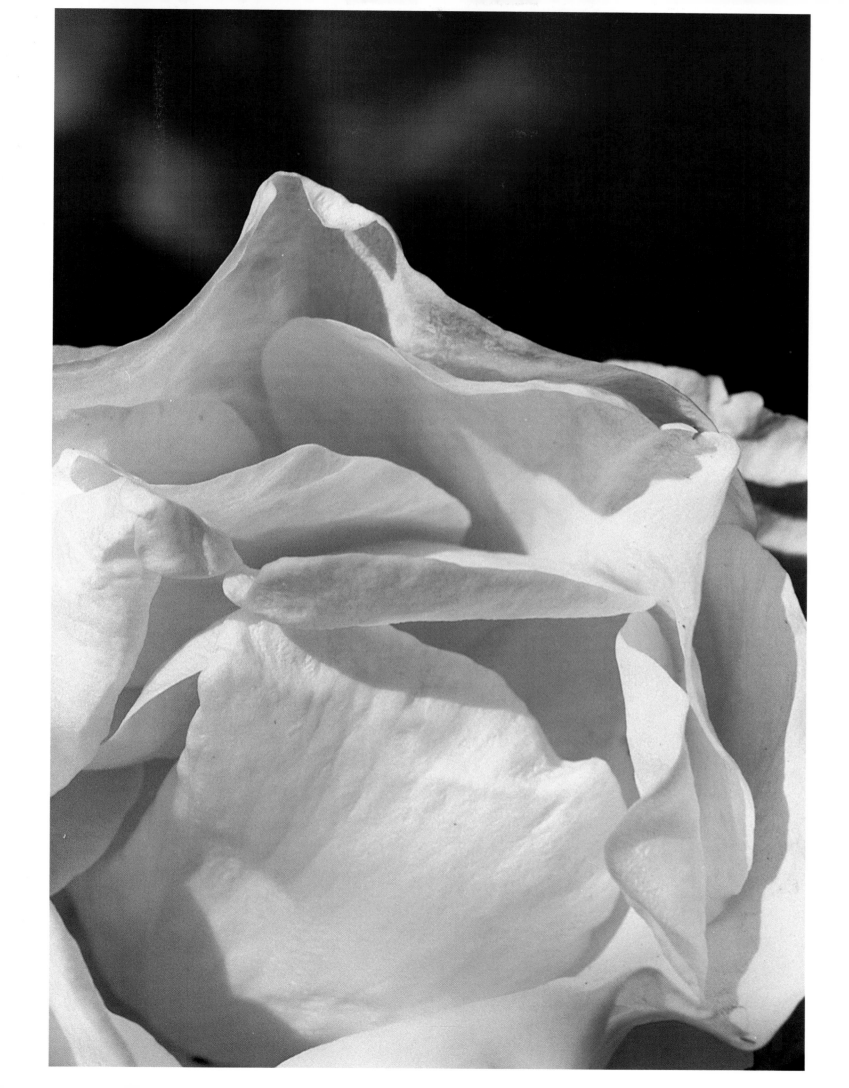

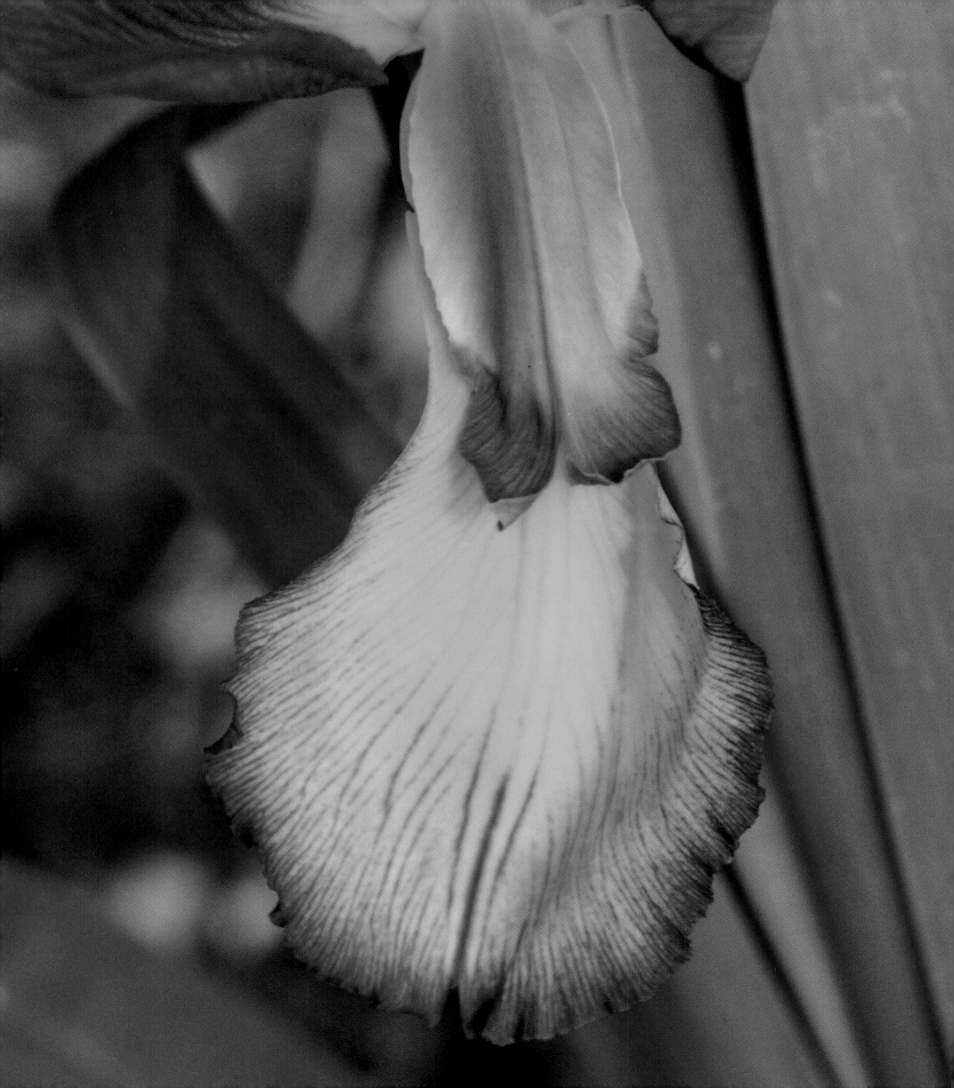

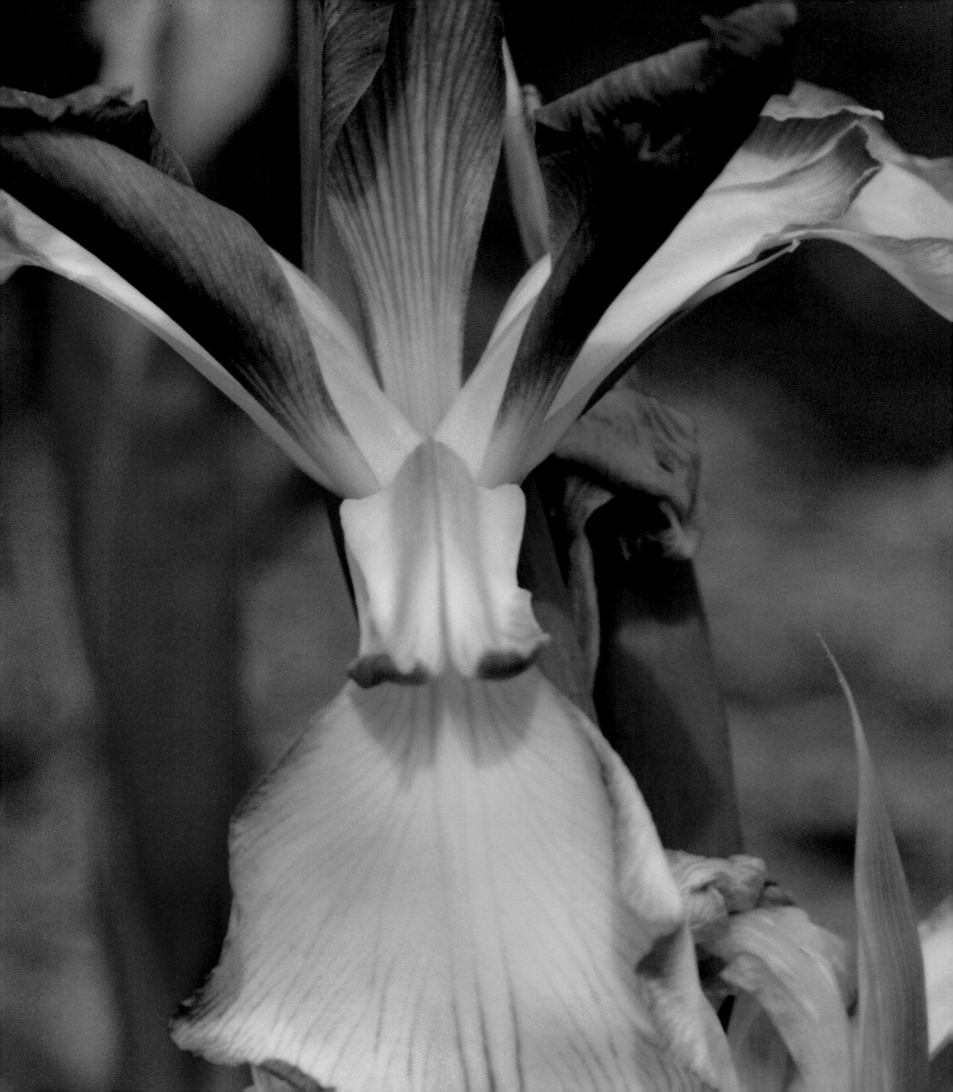

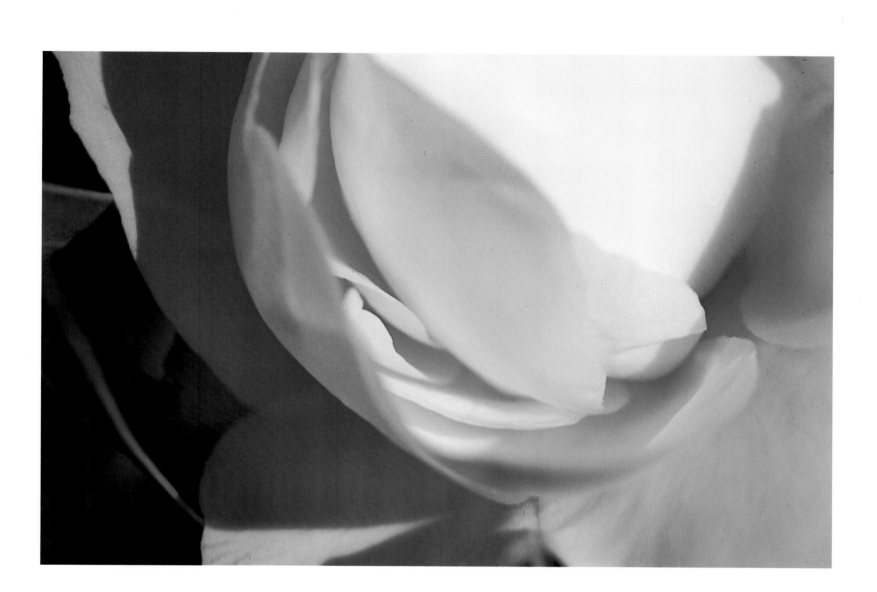

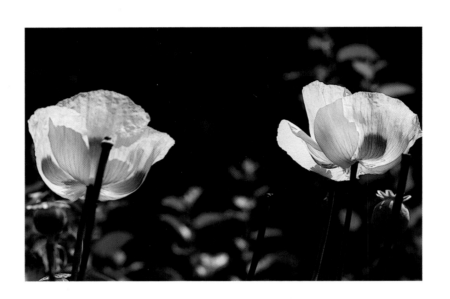

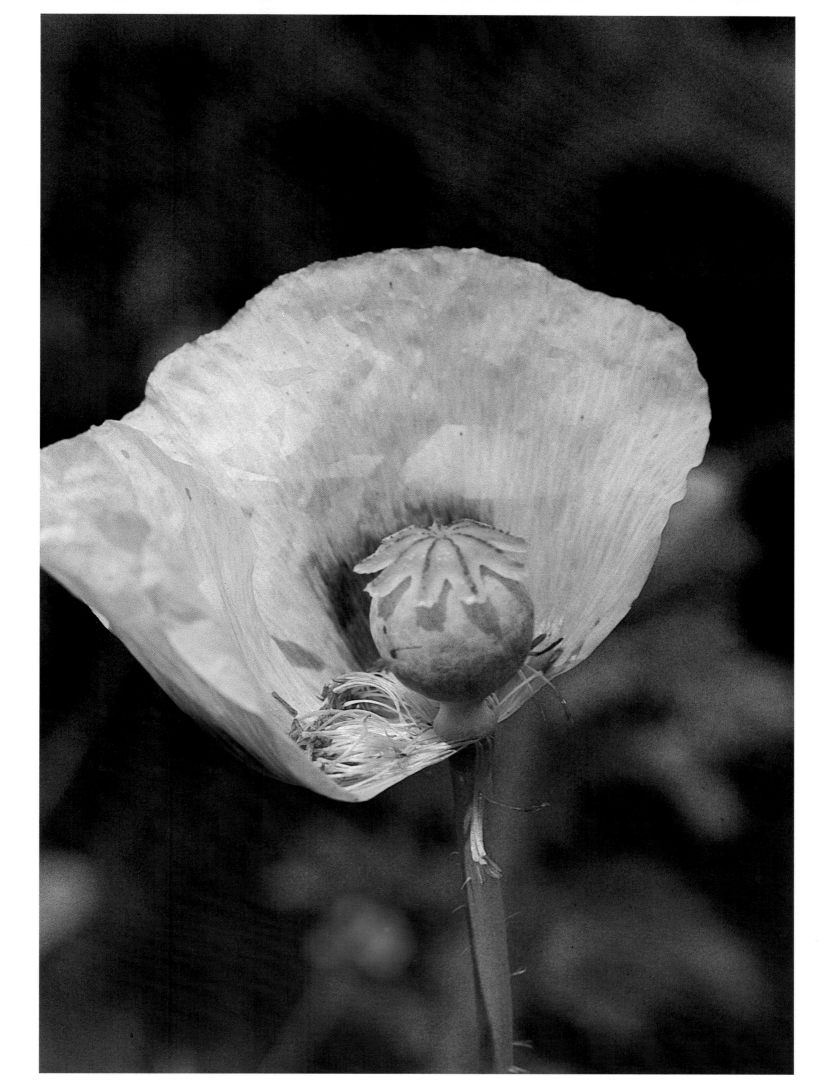

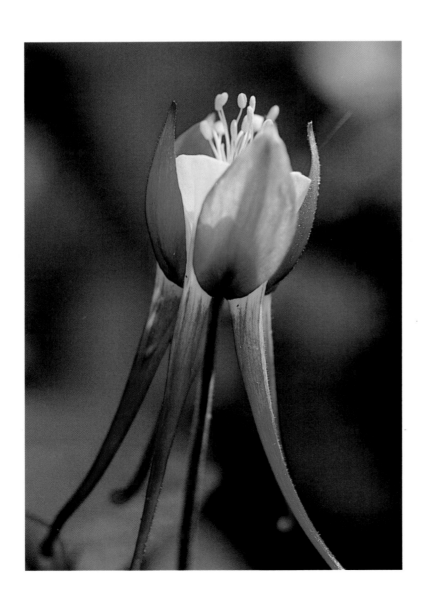

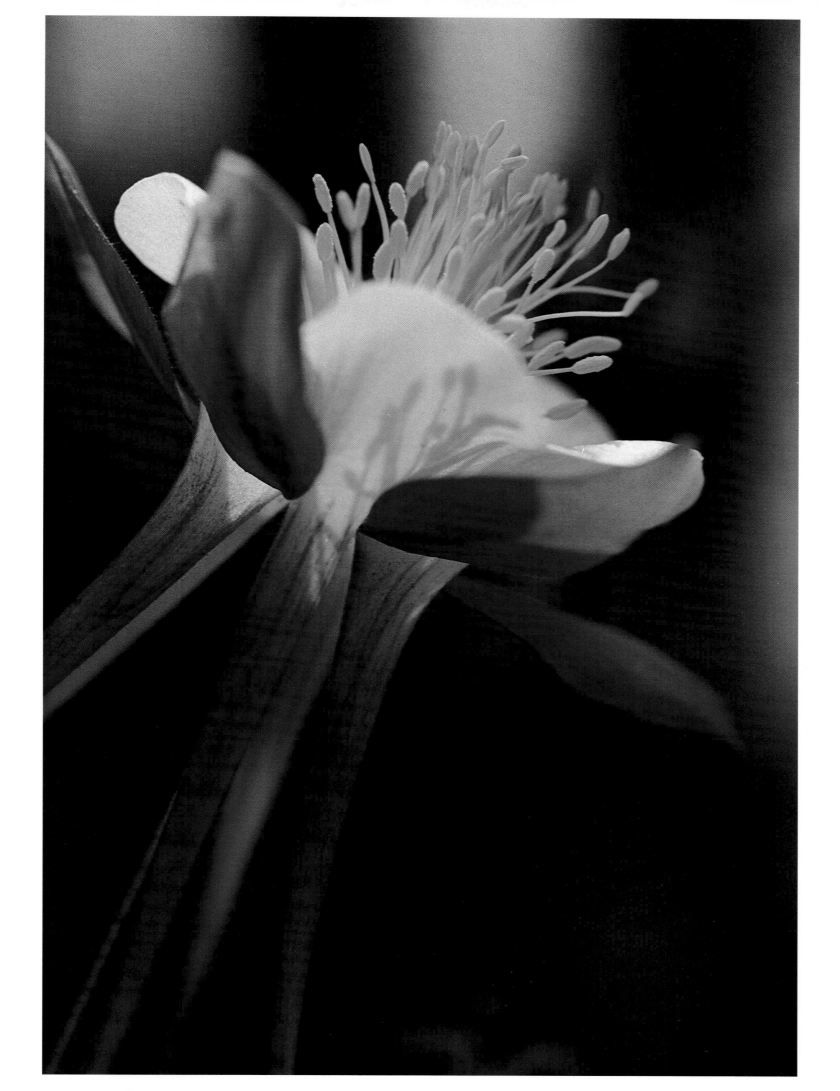

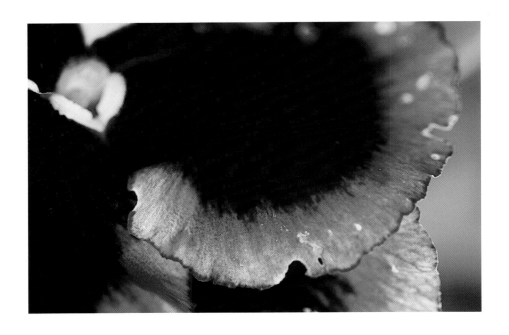

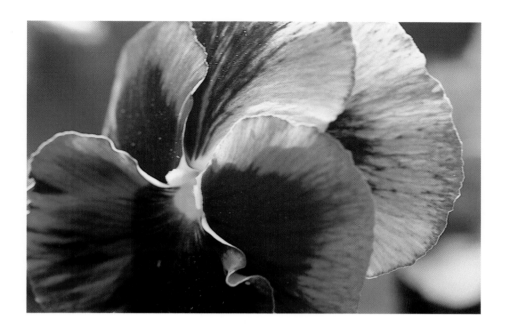

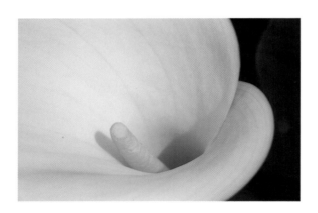

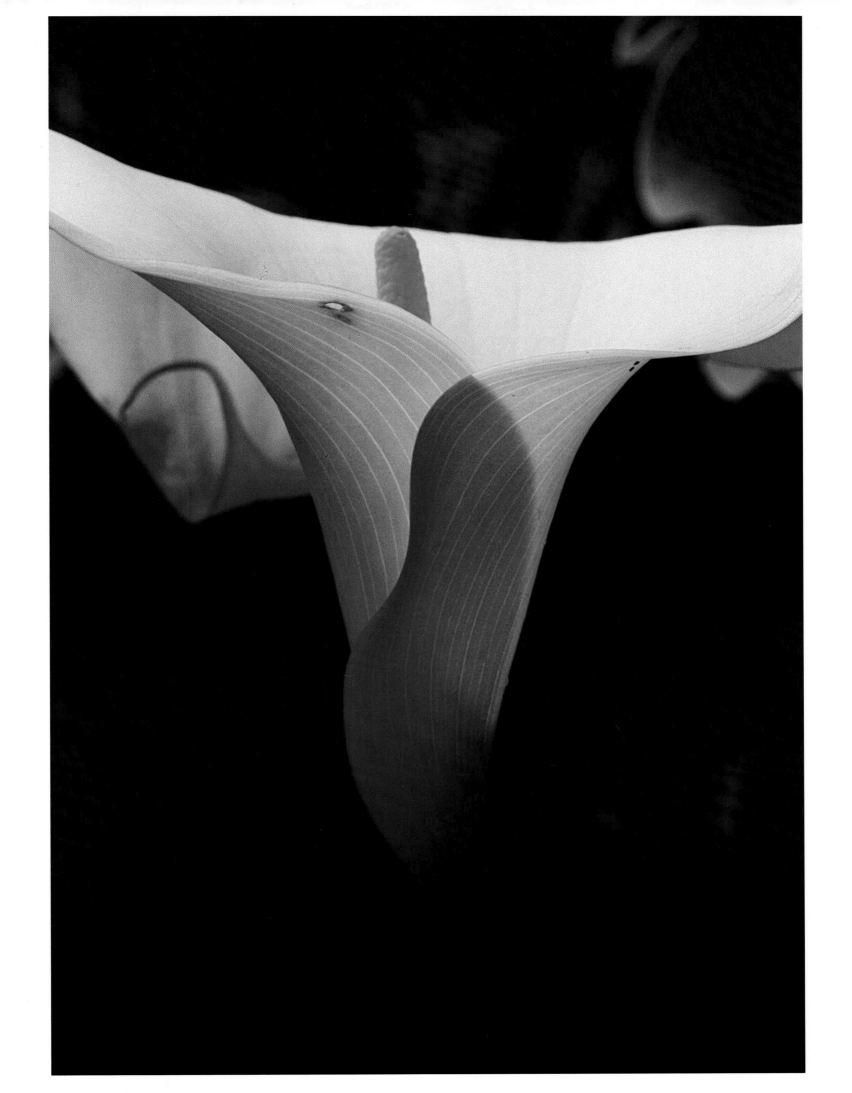

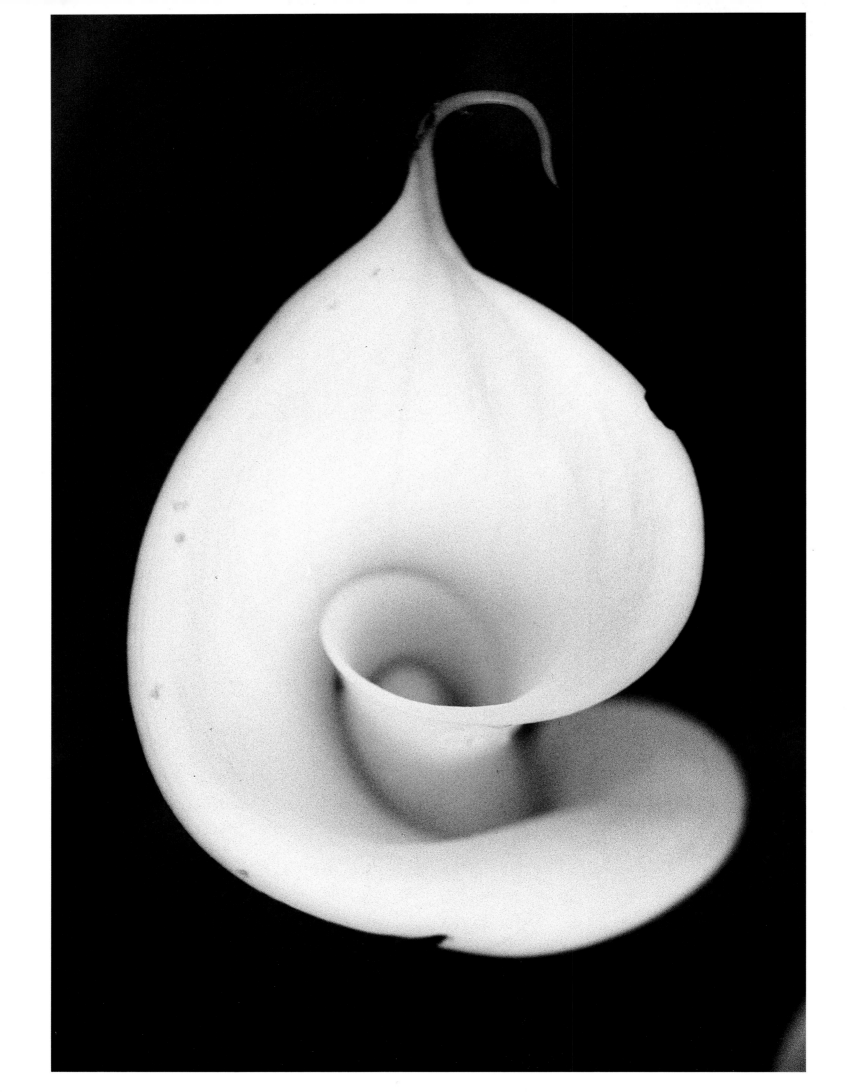

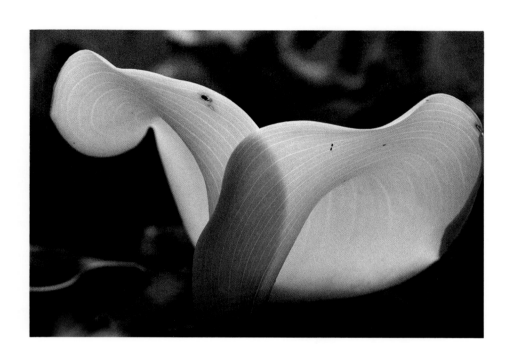

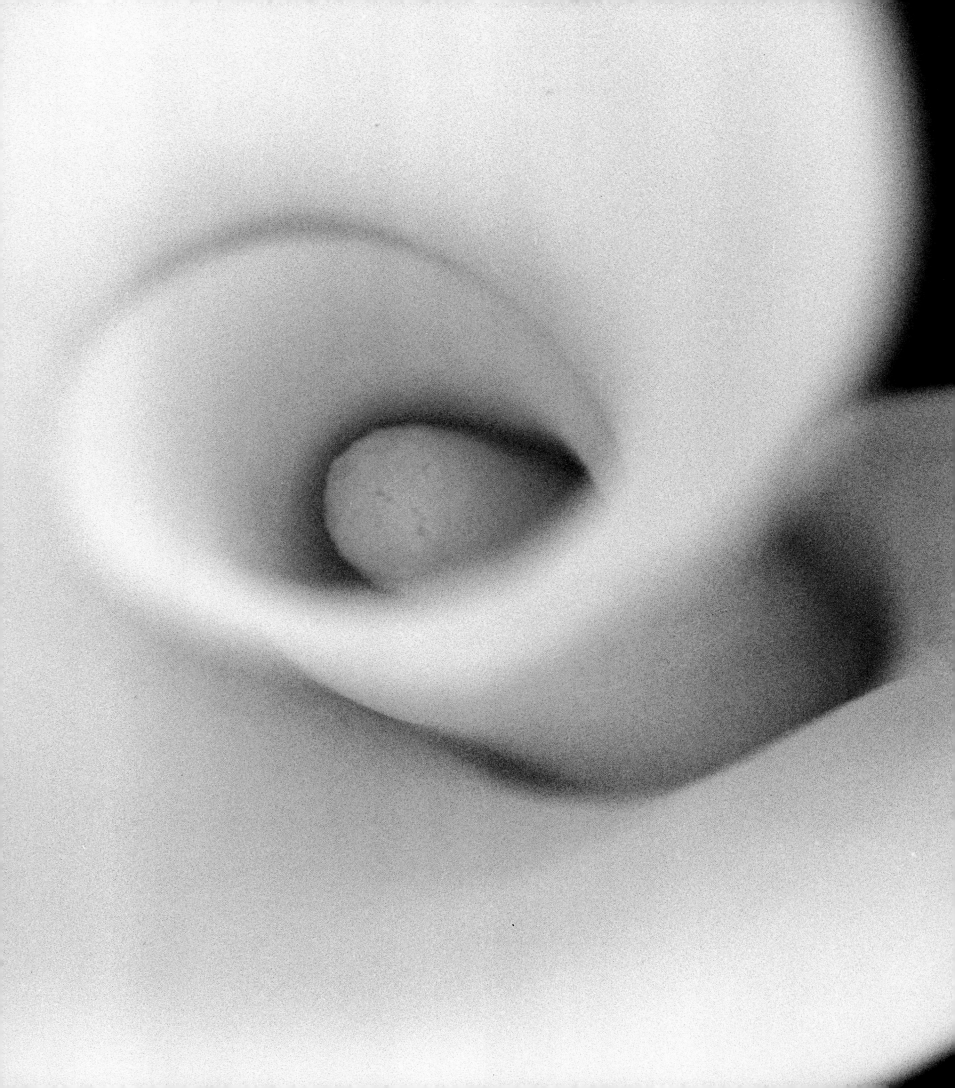

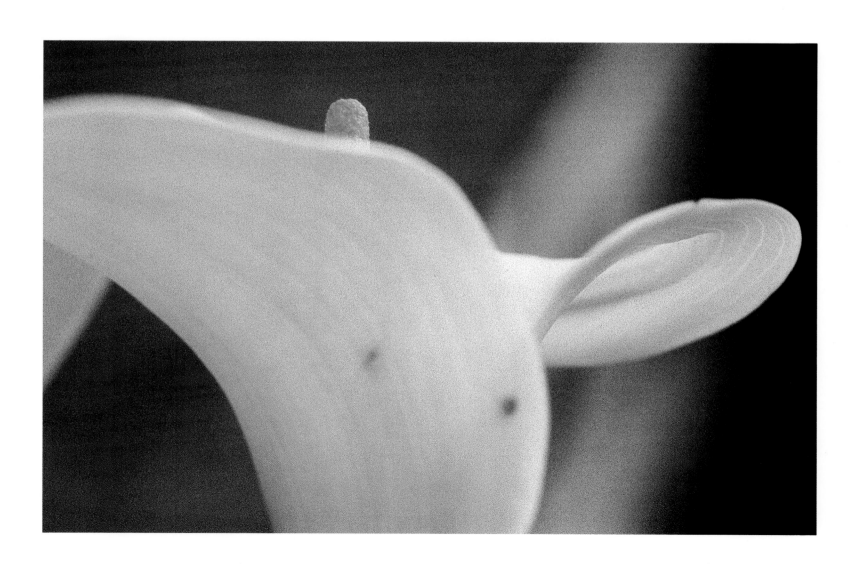

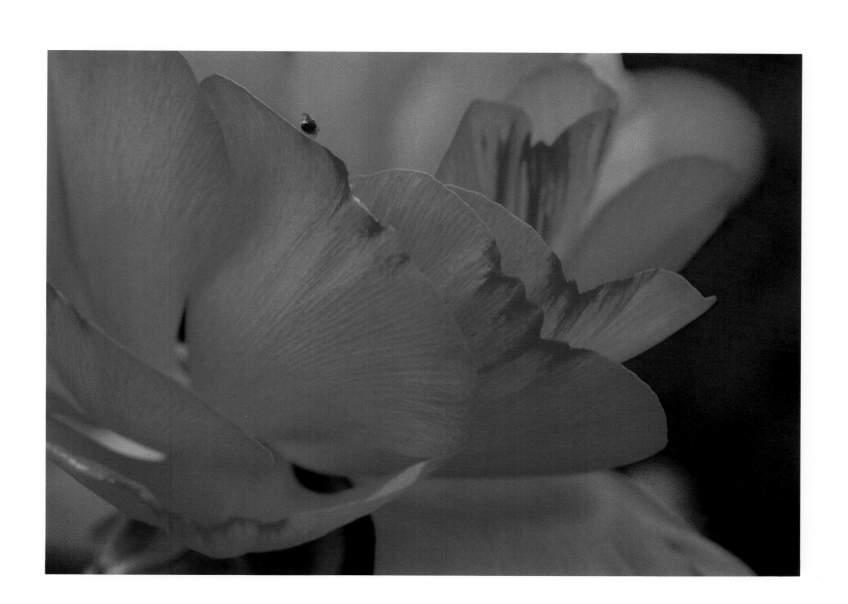

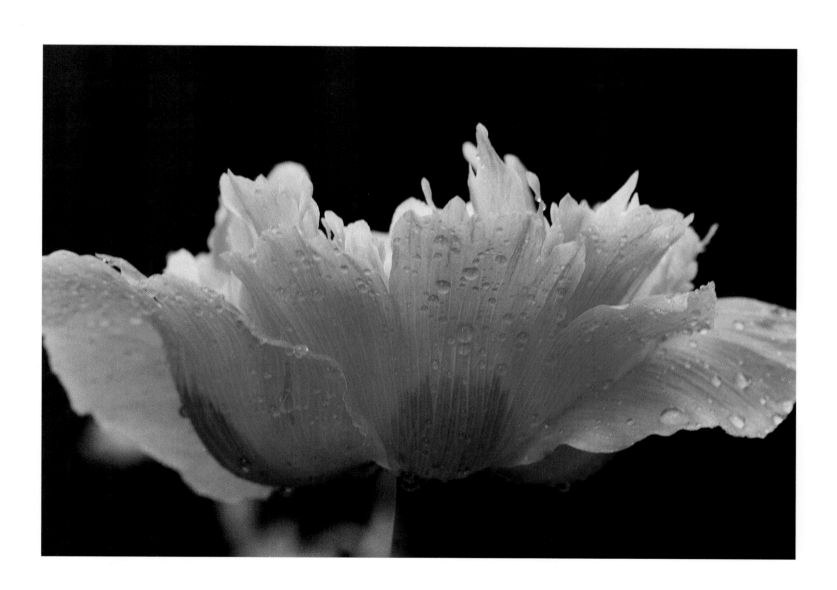

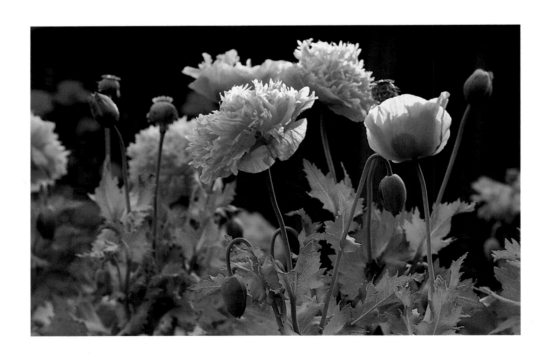

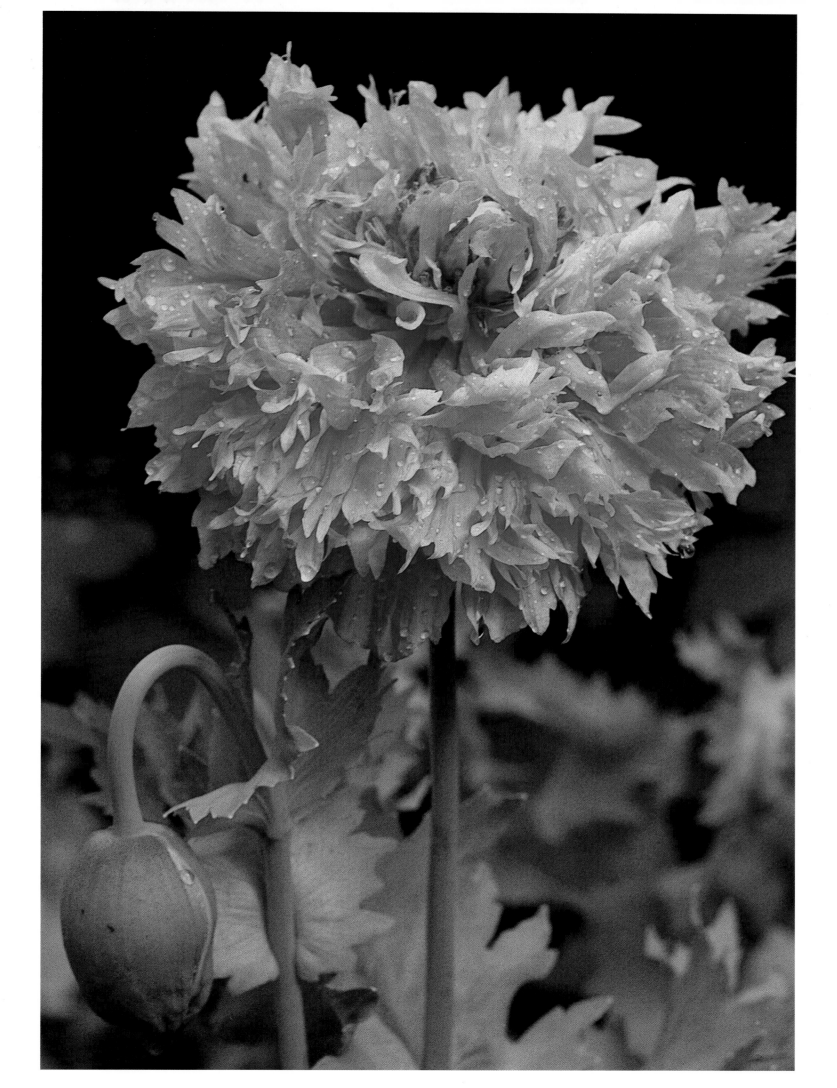

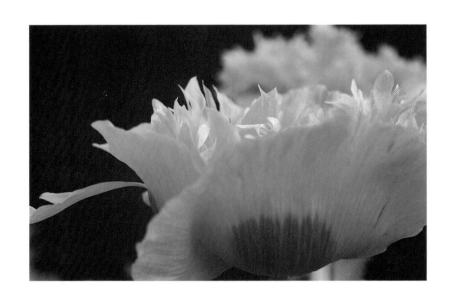

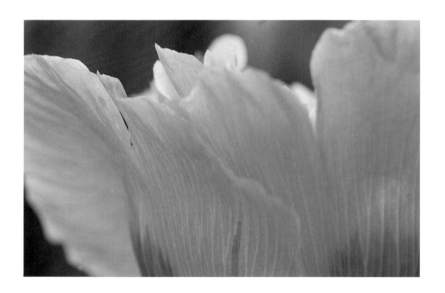

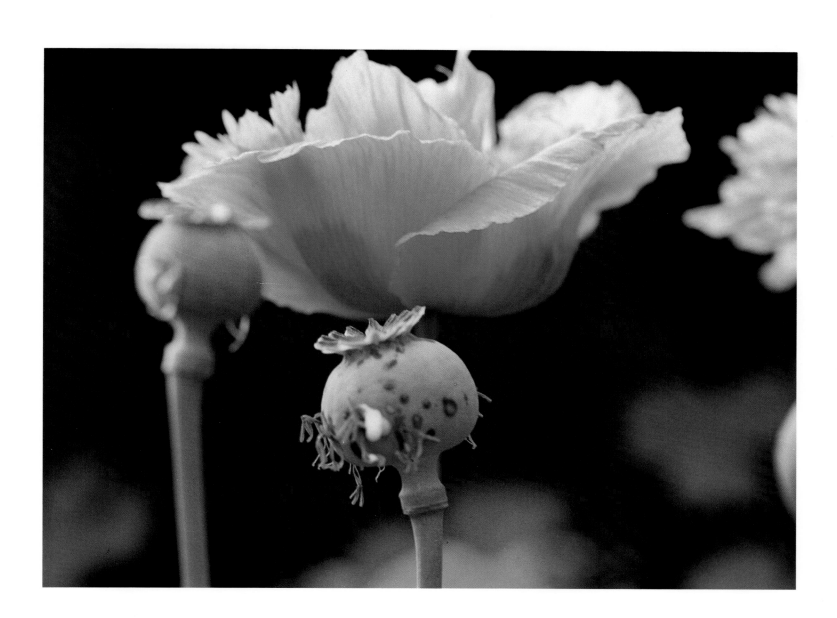

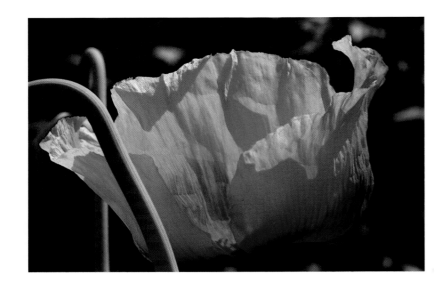 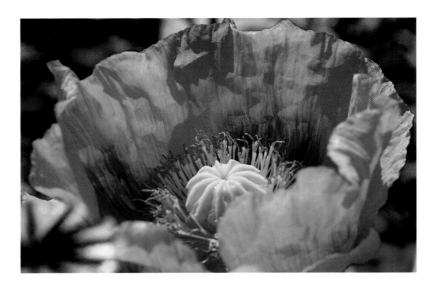

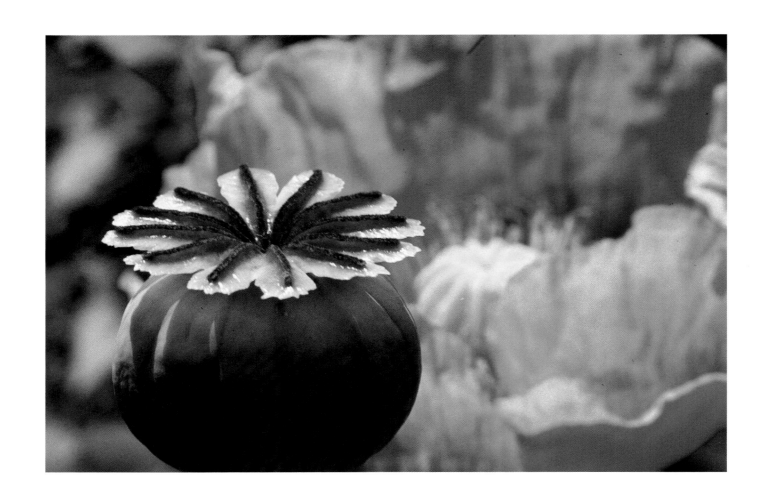

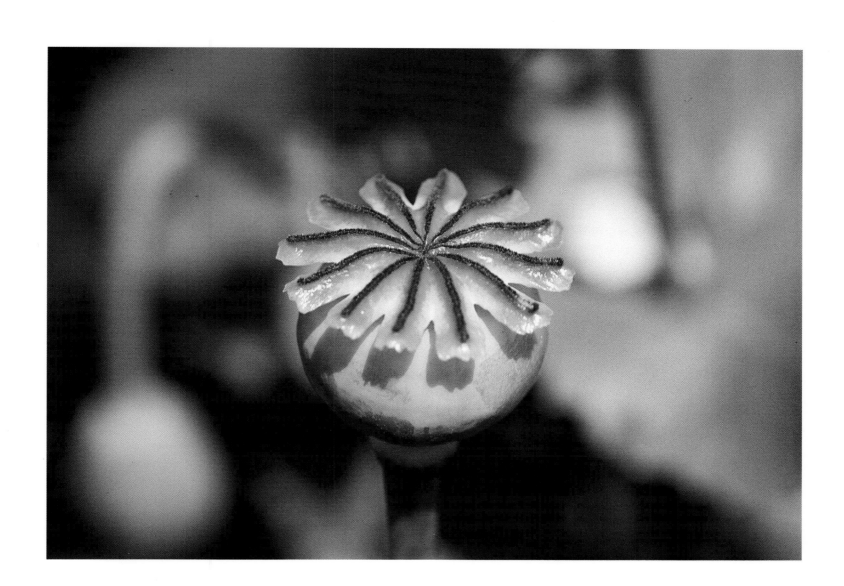

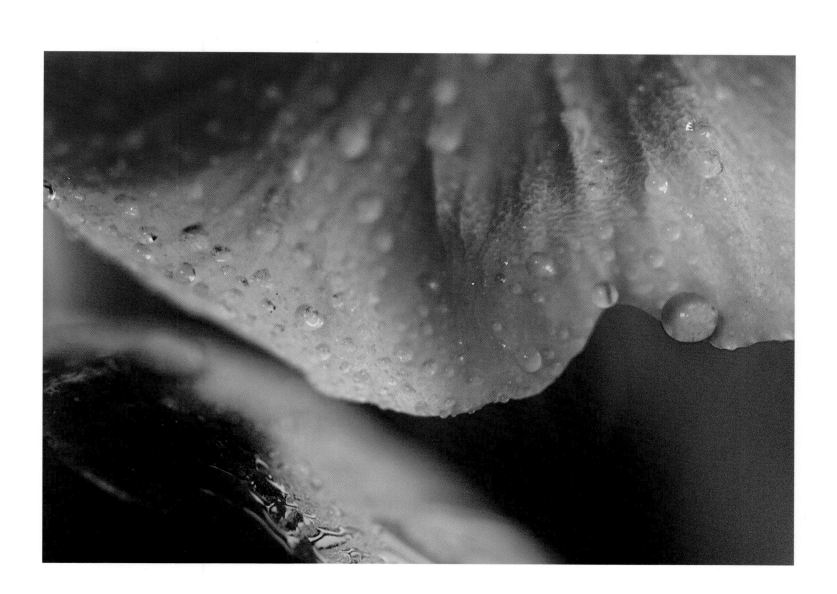

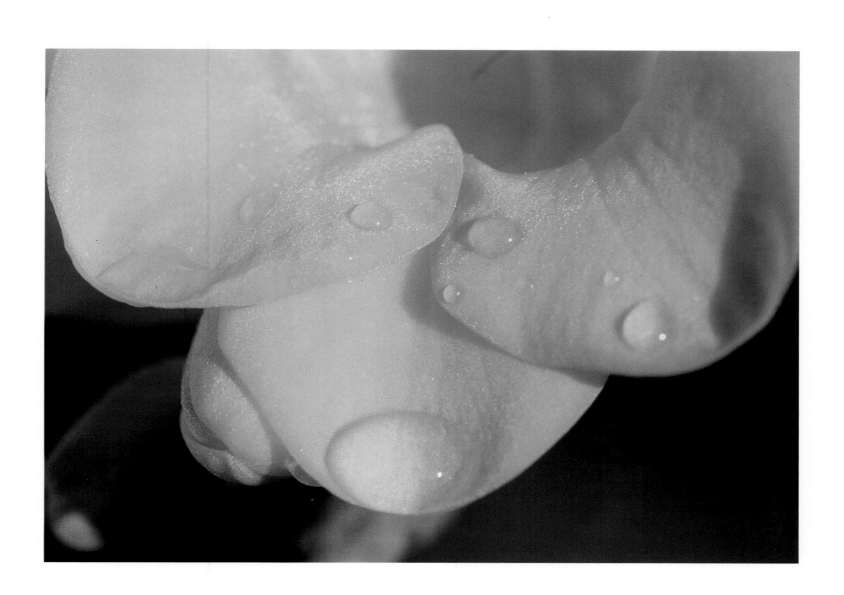

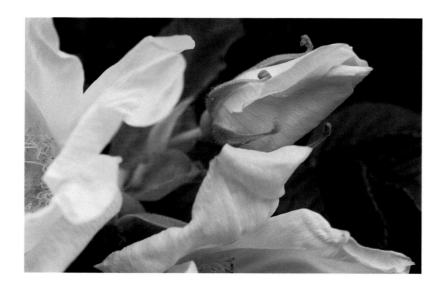

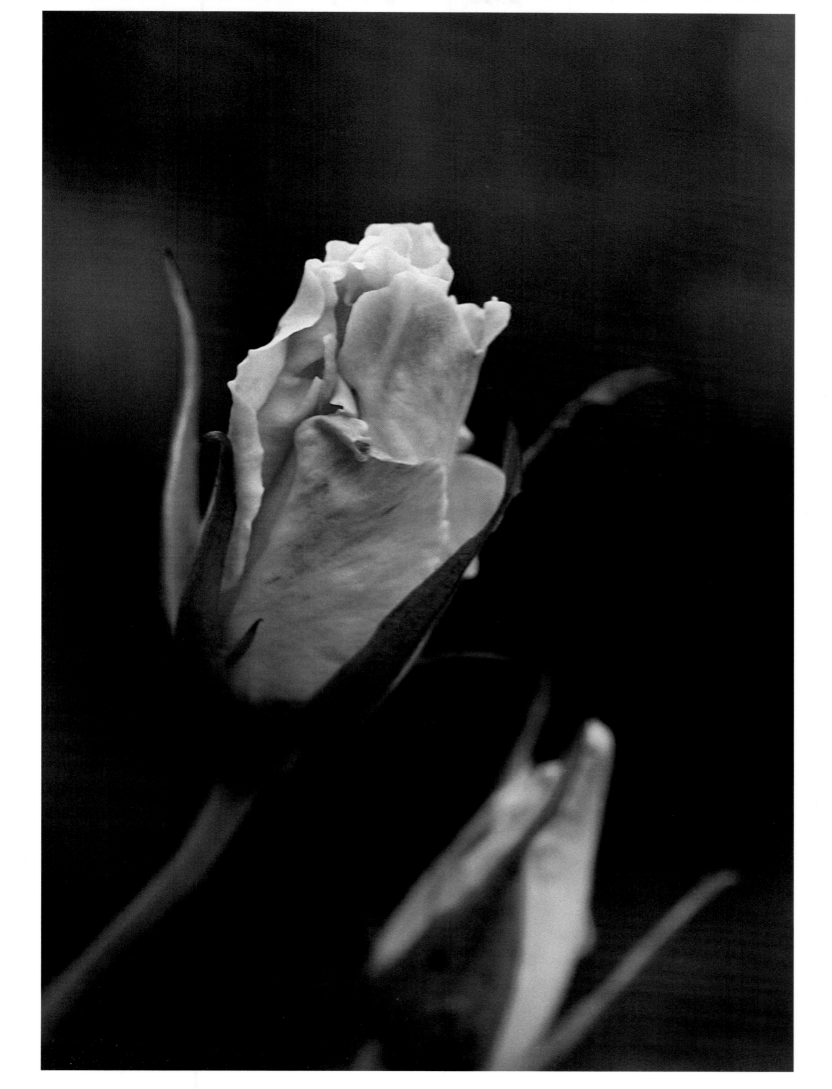

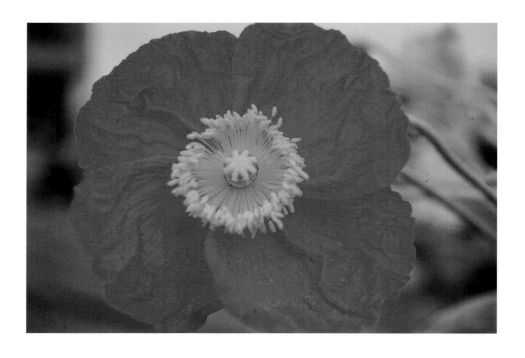

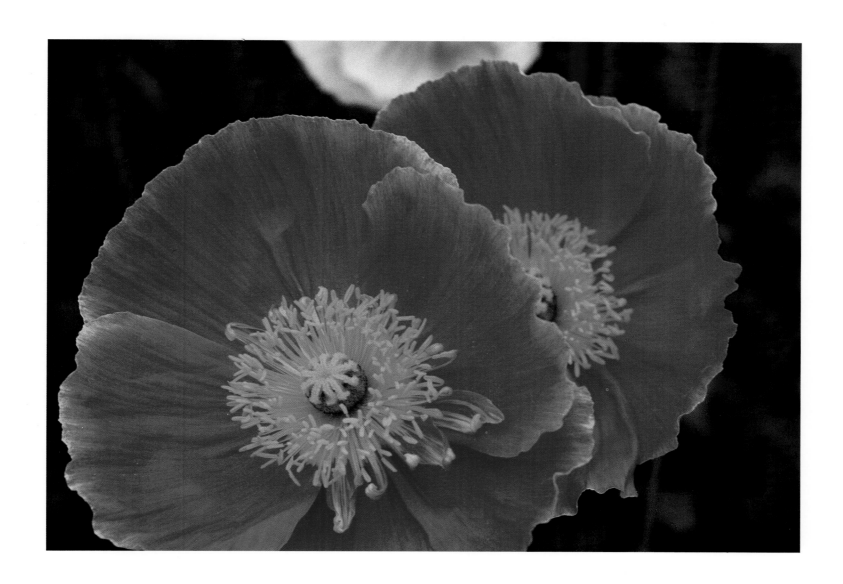

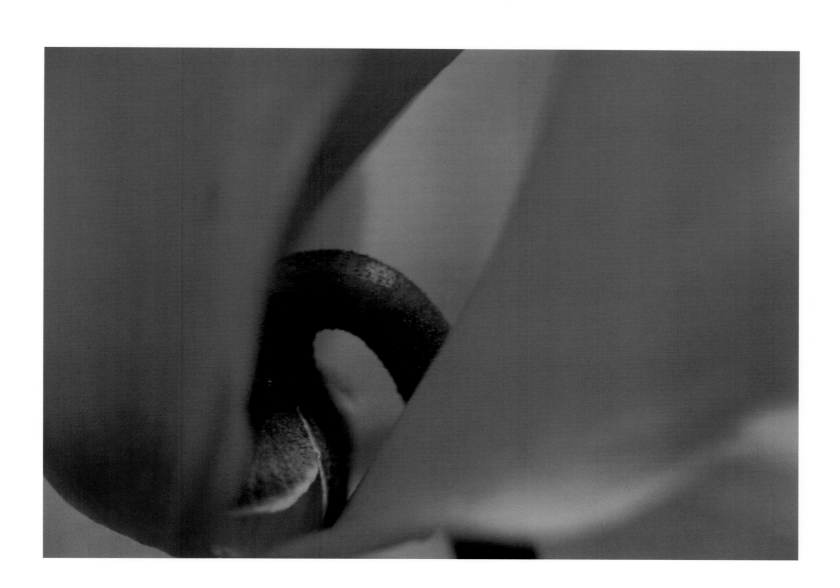

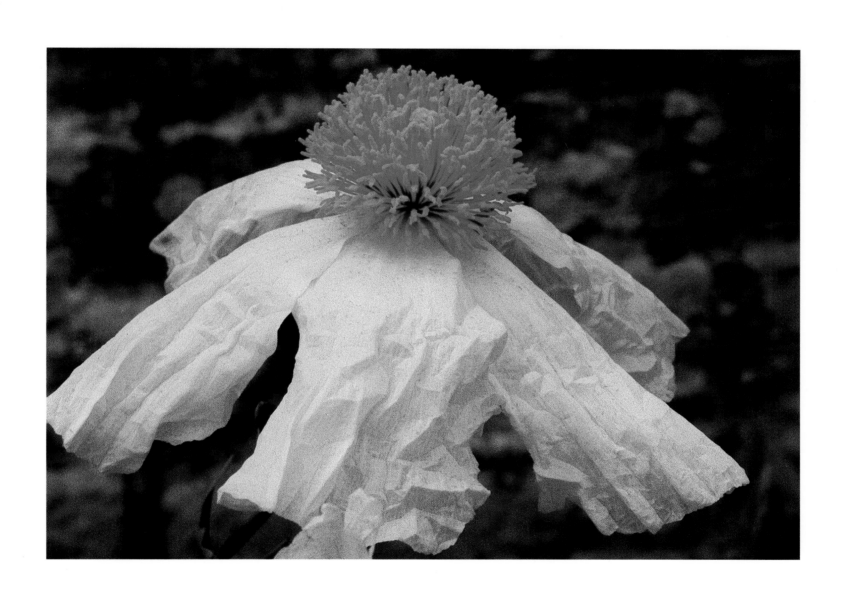

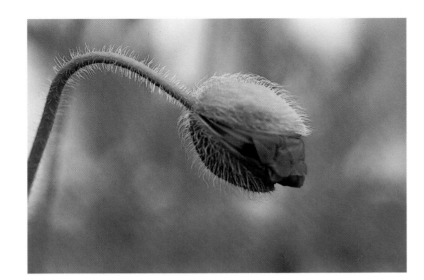

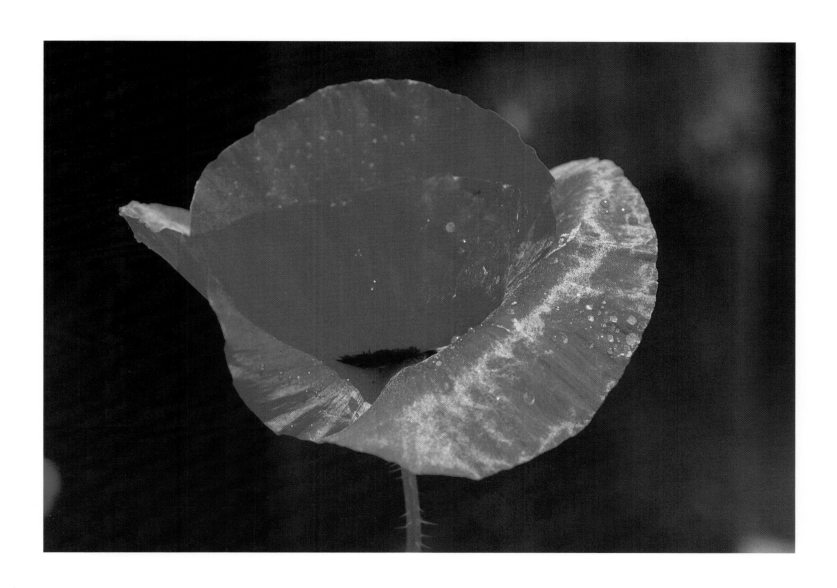

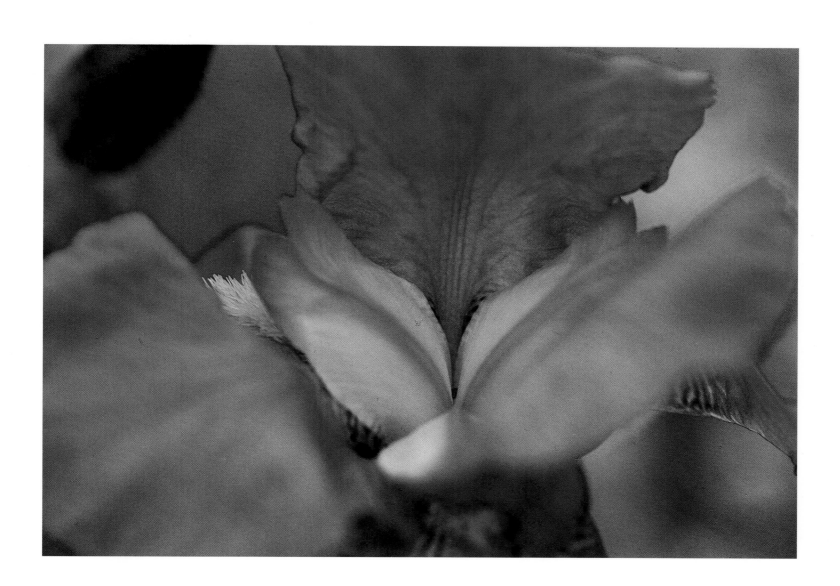

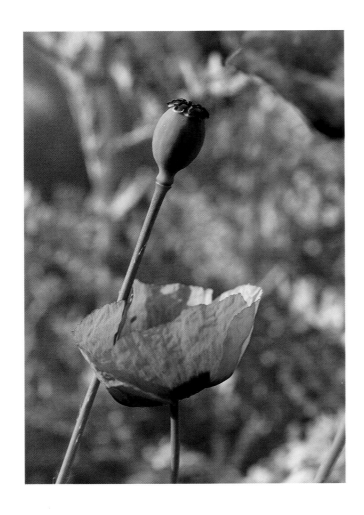

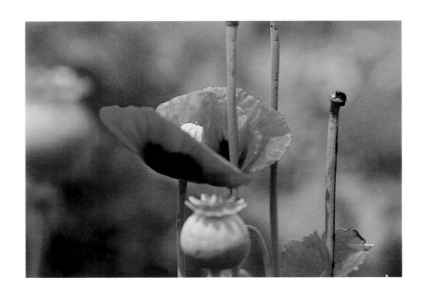

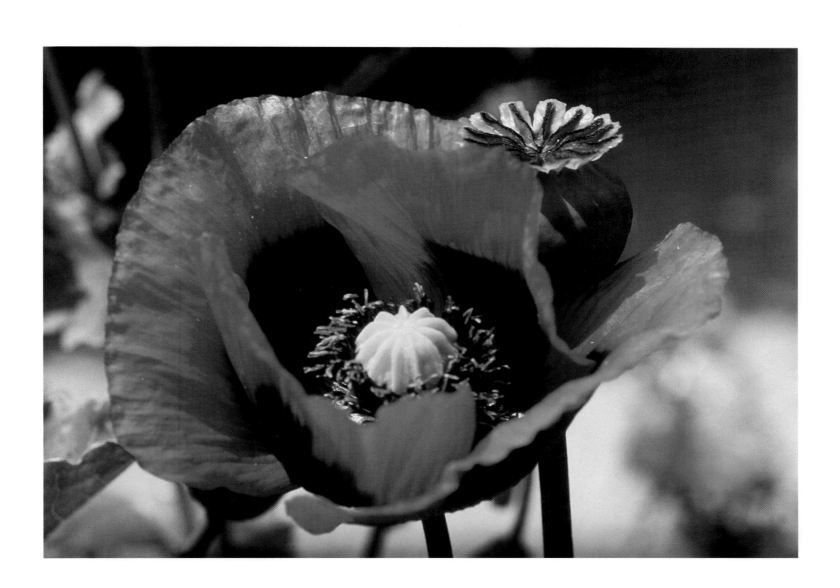

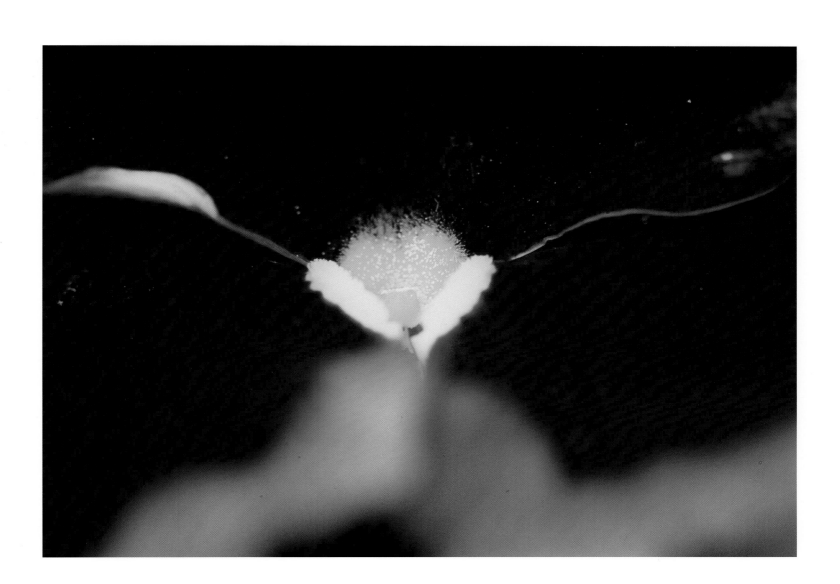

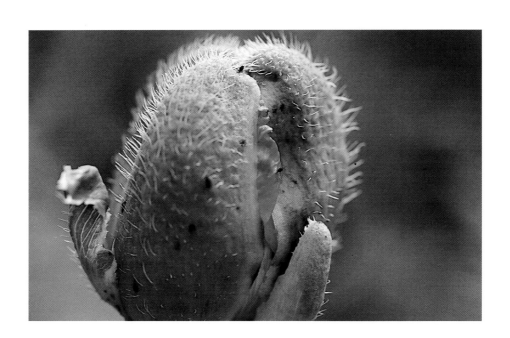

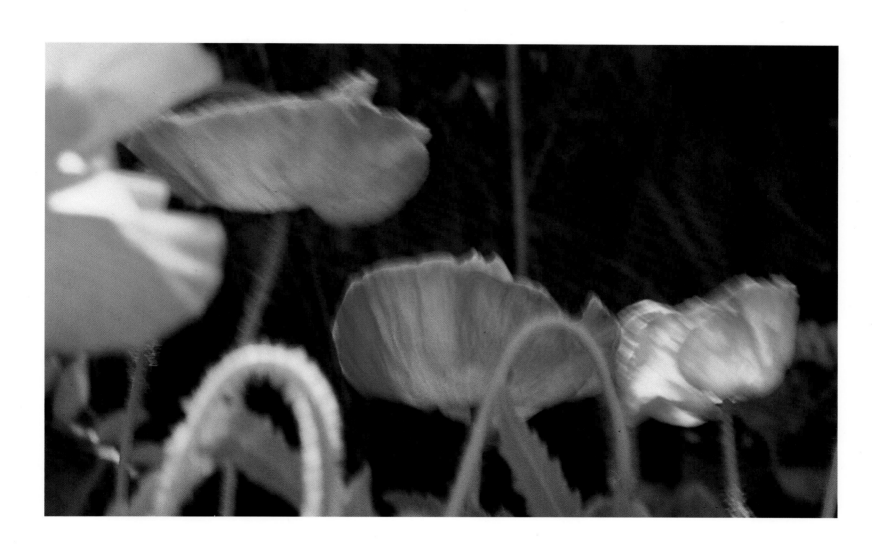

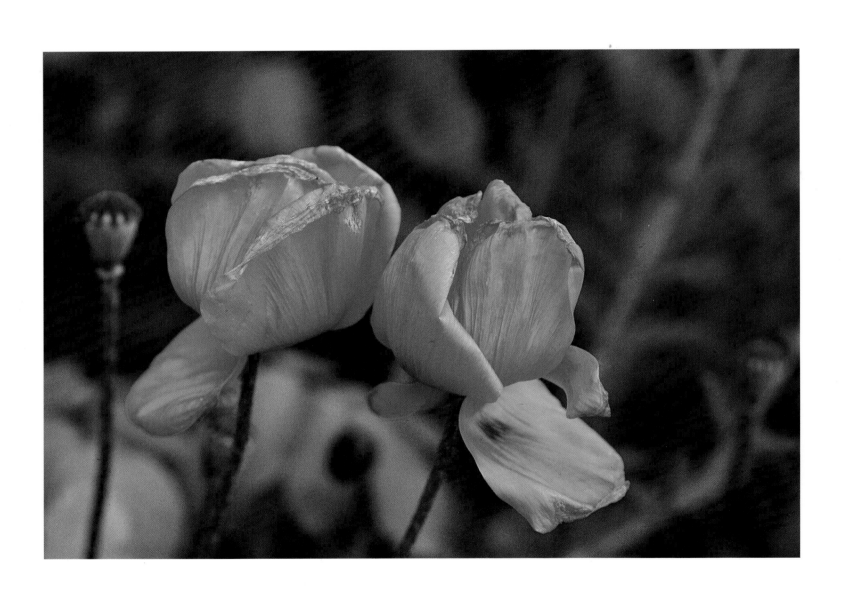

Acknowledgements

The pathway to any achievement does not happen single handedly, nor without the necessary inspiration, and support. This project has been the culmination of such input, thus it is appropriate to applaud it.

Inspiration is forthcoming when one's life has been filled with rich experiences. The garden of my grandparents, Joseph and Lilly Rodricks filled with sweet fragrances of poppies, lilies and roses provided me with my first memories of the wonders of nature. My parents, Nobby and Teresa who have enriched my life with both opportunity and example deserve a special thank you.

To my sisters and brother who have, each in their own way, passionately struggled forward in their lives; especially to Conchita, whose words inspired the title of this book and reflect the sensitivity, depth and passion with which she reaches other lives in friendship.

To Suniti Namjoshi for allowing me to reprint her poem, 'I Give Her The Rose', first published in The Jackass and the Lady, (Calcutta: Writers Workshop, 1980).

To each of the friends over the years who have supported, encouraged and tolerated in the name of friendship – they know who they are. To the many people who have supported my work through purchases at exhibitions and through their enthusiasm. To the caretakers of the many gardens I have grovelled about in over the years.

Renate Klein and Susan Hawthorne of Spinifex for believing in this project and their courage to publish it. Renate and Sue have been a source of encouragement and friendship and I owe much to their support of my work.

Sylvana Scannapiego for her expertise and advice in method. And Olga Kalavrianos for her responsibility in technically translating the design layout of the book. Katrina Bryce who painstakingly sought out the botanical names for the list of plates. It is necessary to also applaud the scholarship of Barbara Walker, whose fine book, The Women's Encyclopedia of Myths and Secrets, Harper & Row 1983, provided a single and valuable resource in the naming of each plate.

Most of all for Colleen Lindner, to whom this project is dedicated – for her inspiration and assistance, her love and unfailing support. You taught me to see flowers again, your passion and love breathed new life into the rhetoric of friendship – ours is a friendship that is made of the very complexity, passion and richness found in flowers and it is hoped that this, a celebration of our friendship, is reflected herein.

All of us should take some time to read Virginia Woolf. Her prolific work displays a unique insight into nature and humanity, her vision, often misunderstood, has had a strong influence in reshaping my own 'way of seeing'.

Finally, the paintings of Georgia O'Keefe's Flowers have given me hours of pleasure and inspiration. Thus in presenting this book to you it is appropriate to echo her words –

> 'Whether the flower or the color is the focus I do not
> know – I do know that the flower is painted large to
> convey to you my experience of the flower – and what
> is my experience of the flower – if it is not color''

Georgia O'Keefe, 1950

For all the women who each day of their lives struggle passionately forward in resistance to injustice often in silence but sometimes out loud.

It is hoped that this book is received with the same amount of pleasure that each aspect of the project gave me whilst putting it together.

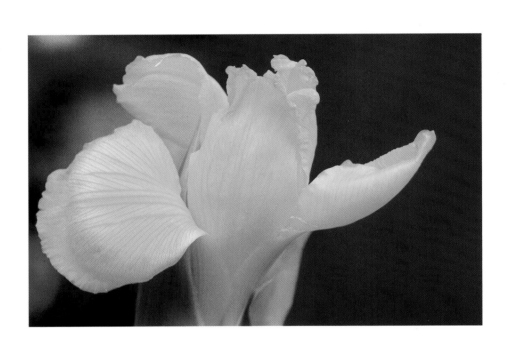

Notes

The photographs in this book were mainly taken in local gardens of friends around Geelong, and in my own garden in South Geelong. A few were the result of pleasant expeditions to gardens such as Como House, a National Trust property in Melbourne whose garden is cared for by a small team led by head gardener, Katrina Bryce. Also, the Geelong Botanical Gardens which provide me with solace and pleasure in spring and summer. The international component of flowers in this book were photographed at Giverny in France in the gardens of the artist Claude Monet, and last but by no means least, the Gardens of Sissinghurst Castle in Kent, Britain, home of Vita Sackville-West and Harold Nicolson where I spent one of the most memorable days of my life in the summer of 1990.

Whilst photographing flowers and other aspects of nature, I have always maintained a philosophy of non-interference with the subject. I have never cut, placed, trampled, held or pushed out of my way any of the subject material.

The photographs have been taken in natural light, and always with a hand-held camera.

The equipment used is mainly a Pentax 35mm camera and a 100mm f 2.8 macro lens. A few of the frames have been taken with a Bronica ETRSi, and standard 75mm lens. The film has been a combination of Kodak Ektar and Fujicolour HG and HR negative film, which has then been transferred to Print film with the assistance of Bondcolour Laboratories Melbourne, Vic. Australia, thanks especially to Sam and Michael, who indulged the urgency of the project requirements.

𝒮PINIFEX Press Pty Ltd
504 Queensberry Street
North Melbourne, Vic 3051
Australia

First published by 𝒮PINIFEX Press, 1992

Production by Sylvana Scannapiego,
Island Graphics Pty Ltd
Typeset in Australia
by Optima Typesetting
Printed in Hong Kong by
South China Printing Co. (1988) Ltd

National Library of Australia
Cataloguing-in-Publication entry:

CIP

Fonseca, Lariane, 1951-
 If passion were a flower

 ISBN 1 875559 06 X

1. Fonseca, Lariane, 1951- 2. Photography of plants. 3. Flowers – Pictorial works.
I.Title.

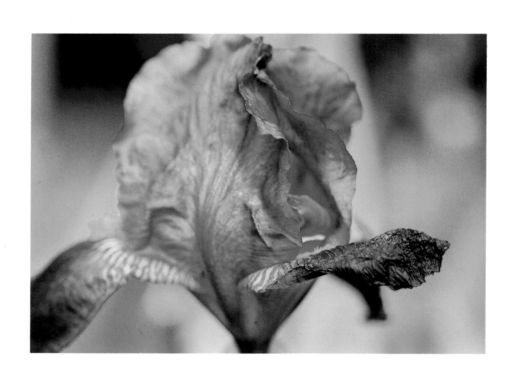

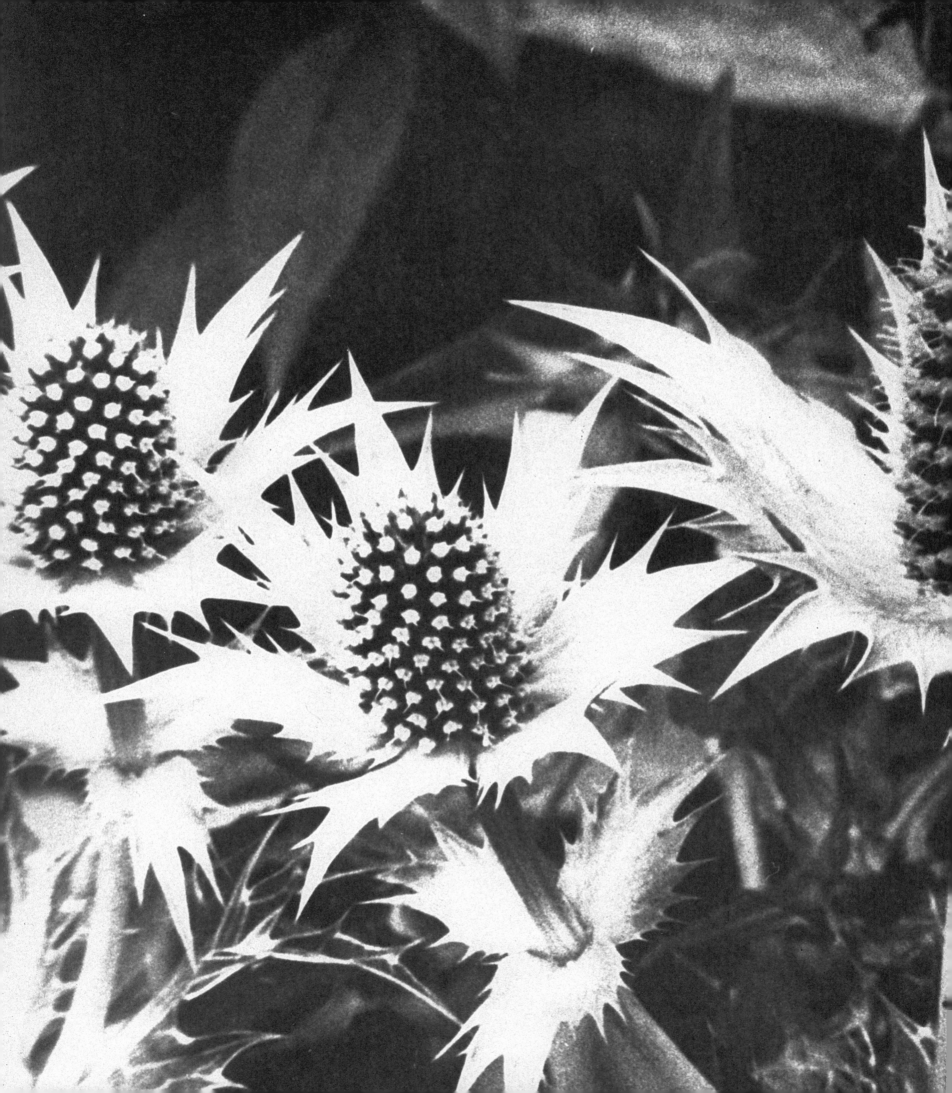